IMAGES
of America

INDUSTRIA
BALTIMORE

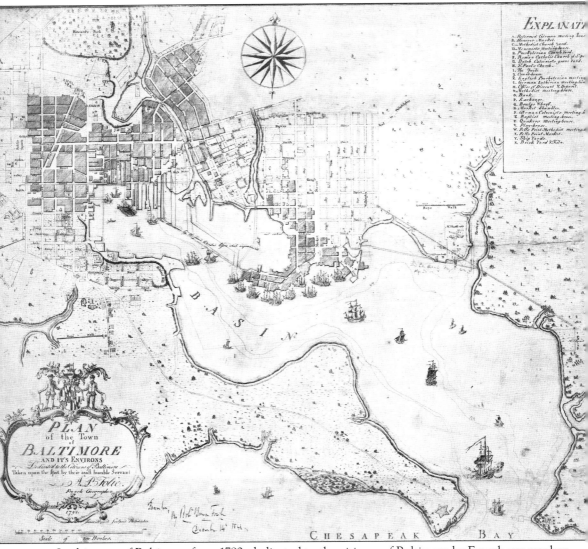

IMAGES
of America

INDUSTRIAL BALTIMORE

Tom Liebel

ARCADIA
PUBLISHING

Published by Arcadia Publishing
Charleston, South Carolina

Printed in the United States of America

Library of Congress Catalog Card Number: 2006921053

For all general information contact Arcadia Publishing at:
Telephone 843-853-2070
Fax 843-853-0044
E-mail sales@arcadiapublishing.com
For customer service and orders:
Toll-Free 1-888-313-2665

Visit us on the Internet at www.arcadiapublishing.com

CONTENTS

ACKNOWLEDGMENTS

The following archives were invaluable sources of the historic photographs and other documents found in this book. I would like to thank these institutions and individuals for providing assistance in accessing these archival materials: The Library of Congress, the Historic American Building Survey/ Historic American Engineering Record (HABS/HAER) and Farm Security Administration–Office of War Information (FSA-OWI) Collections in particular, Jeff Korman and Nancy Derevjanik with the Maryland Department of the Enoch Pratt Free Library, Carrie Albert with the Baltimore Museum of Industry, Laurie Feinberg with the Baltimore City Department of Planning, Eddie Leon with the Baltimore City Commission for Historical and Architectural Preservation (CHAP), and Joanne Stallings and Andy Powell with Struever Brothers, Eccles, and Rouse, Inc.

I would also like to thank the Baltimore Camera Club and Constellation Energy Group for providing permission to use specific images held in the Enoch Pratt Free Library's Maryland Department Photographic Archives.

Furthermore I would also like to thank my editor at Arcadia Publishing, Lauren Bobier, for first encouraging me to write a book on Baltimore's industrial legacy and then keeping me on track throughout the process of researching and producing this book.

Finally I would like to dedicate this book to my wife, Terry, who constantly encourages me to be all that I can, and to my children, Aidan and Cameron, who inspire me and give me great hope for Baltimore's future.

INTRODUCTION

This book is not intended to be an exhaustive compendium of the history of all industrial facilities in Baltimore. Rather the book hopes to document a sampling of sites within the city in order to give the reader a sense of how the city has been transformed over time.

Baltimore has undergone a radical, and frequently painful, transformation over the past 50 years. In 1950, Baltimore's population peaked at almost 950,000 residents. By 2004, Baltimore's population had fallen to just over 635,000, a decline of 33 percent. Of even greater significance than the decline in population was the loss of over 100,000 manufacturing jobs over the same time period, representing 75 percent of all manufacturing jobs in Baltimore. Entire sectors of industry have been lost in this transition, and entire neighborhoods of factories are now abandoned.

With the loss of these industries has come a loss of the understanding of how Baltimore evolved into its current form. Significant portions of the city have been radically transformed by the businesses and industries that occupied the land. The size, shape, and configuration of a variety of features such as roads, shoreline, and neighborhoods have been directly influenced by the industries they supported. Even though these industries may have left the city, the features influenced by these industries remain. This explains a variety of mysteries, such as why is Key Highway as big as it is, and why does it meander where it does? Why are shorelines around the Inner Basin and Middle Branch configured the way they are? In order to comprehend Baltimore's morphology, it is critical to understand the unique set of forces that helped to shape the city.

Baltimore developed as a major city through a distinctive set of circumstances. The city's location on the Chesapeake Bay actually places Baltimore much further west than other port cities on the East Coast of the United States. With 18th- and early-19th-century overland transportation fees costing a great deal more than shipping over water, producers in the mid-Atlantic states found it more economical to ship their goods through the port of Baltimore due to its closer proximity to inland sites.

Baltimore expanded its influence as a transportation hub when the Baltimore and Ohio Railroad was established in 1830 to connect Baltimore to points west, eventually crossing the mountains of Western Maryland to connect with the Ohio River valley. A number of other railroads also had a significant presence in Baltimore, including the Pennsylvania Railroad, Western Maryland Railroad, and Northern Central Railroad. These railroads fundamentally altered the appearance of the city with their extensive marshaling yards, warehouses, and port facilities.

Baltimore also emerged as an industrial center in the 19th century, with a variety of industries capitalizing on the city's unique combination of railroad and port facilities to import from around the world the raw materials required by these industries.

With this growth in transportation and industry came population growth. At the time of the first decennial census enumeration in 1790, Baltimore was the fifth-largest city on the United States with a population of 13,503. By 1830, the city was the second-largest in the nation, comprised of 80,620 residents. In 1840, Baltimore eclipsed the 100,000 resident mark, doubled that by 1860, and then continued a steady progression to 508,957 residents in 1900. The first half of the 20th

century saw explosive population growth, adding 180,000 residents in a single 10-year period between 1910 and 1920 and concluding the population increase in 1950 with 949,708 residents, the sixth-largest city in the nation.

Unfortunately Baltimore has suffered a fate similar to many other "rust belt" cities. As Baltimore's manufacturing sector collapsed in the 1970s and 1980s, people fled "the Land of Pleasant Living" in droves, some moving to the rapidly expanding suburbs around Baltimore, while others left the entire region. Today Baltimore has begun to reinvent itself by reclaiming many of the abandoned industrial sites and converting them to new uses. It is this salvaging of the past to reuse for the future that provides Baltimore a significant amount of the city's unique character.

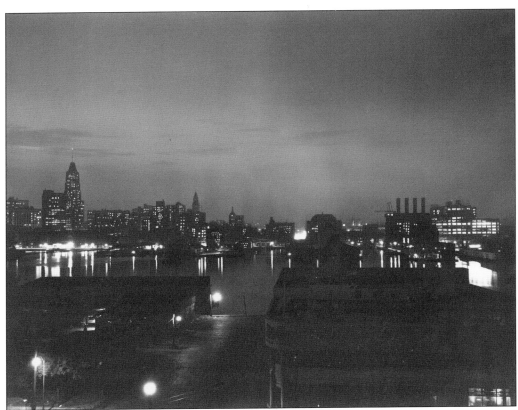

Baltimore's Inner Harbor glows in this photograph from 1950. The growth of Baltimore's commercial sector is evident through the number of office towers illuminated against the nighttime sky. (Courtesy of the Enoch Pratt Free Library, Central Library/State Library Resource Center, Baltimore, Maryland.)

One

EARLY INDUSTRY

Water was the preferred means of power for factories in the early 19th century. Driving everything from flour mills to drop forges to looms, the directed flow of water provided motive power prior to the advent of steam or electric power.

The mills that lined the Jones Falls primarily produced cloth for a variety of uses, from the canvas used for sails on clipper ships to the cloth used in men's suits. However mill buildings along the Jones Falls also housed flour mills, iron foundries, and even a rubber manufacturing plant.

While none of the mills produce cloth anymore, a surprisingly large number of mills have found new lives as everything from artists' studios to cheap storage to high-end retail establishments. Many more mills than one might expect still exist, due in no small part to the simple and sturdy construction of these mills that have withstood the tests of time.

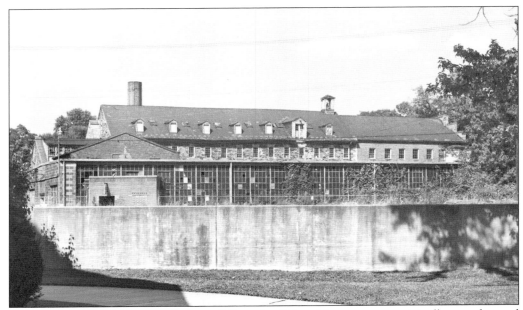

Mount Washington Mill sits on the Jones Falls and, utilizing this waterpower, originally manufactured textiles. After 1923, it produced fasteners and other miscellaneous metal components for the Maryland Nut and Bolt Company. This complex was added on to over time, with the original stone mill building dating to 1810, making it the third-oldest extant mill building in the United States, while other portions were constructed as recently as the 1950s. (Courtesy of the Library of Congress, Prints and Photographs Division, Historic American Building Survey/Historic American Engineering Record [HABS/HAER].)

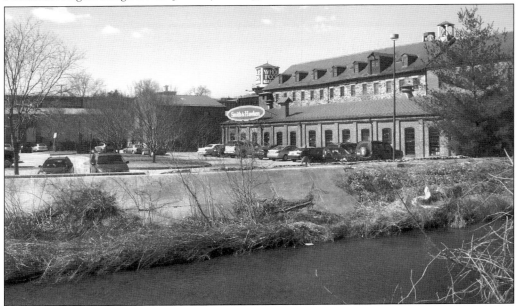

Today Mount Washington Mill has been redeveloped as a successful high-end retail center. A number of the interconnected buildings on the site were demolished to create space for parking lots and walkways between the remaining structures. (Courtesy of the author.)

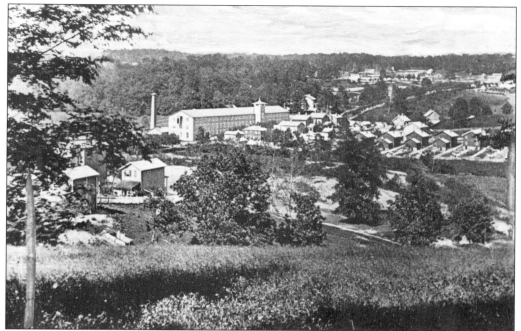

In this 1867 view from Druid Hill, the recently constructed Druid Mill is visible, as well as numerous houses built for the workers in that and other nearby mills. The smokestack to the left of the mill indicates that even at this early stage of development, waterpower was not sufficient to consistently power the mills, and therefore steam power was also provided. (Courtesy of the Enoch Pratt Free Library, Central Library/State Library Resource Center, Baltimore, Maryland.)

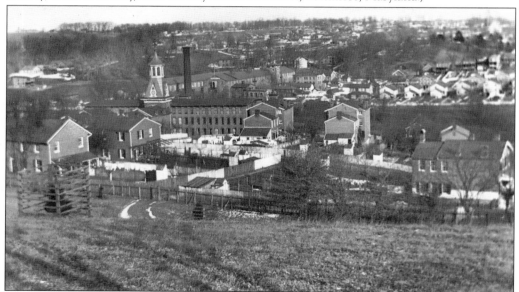

In this January 27, 1891, view from Druid Hill Park, the quarter-century of development is clearly visible, with Meadow Mill in the foreground, an enlarged Druid Mill in the background, and much less open space and trees in evidence. (Courtesy of the Baltimore Camera Club and the Enoch Pratt Free Library, Central Library/State Library Resource Center, Baltimore, Maryland.)

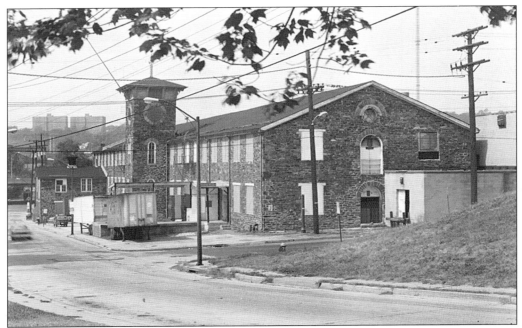

The original Druid Mill building with its central tower is still in very good condition. This building, the largest mill constructed of stone in Maryland, has been used for several decades by Life-Like Products, manufacturers of plastic components and model train paraphernalia. (Courtesy of the Library of Congress, Prints and Photographs Division, HABS/HAER.)

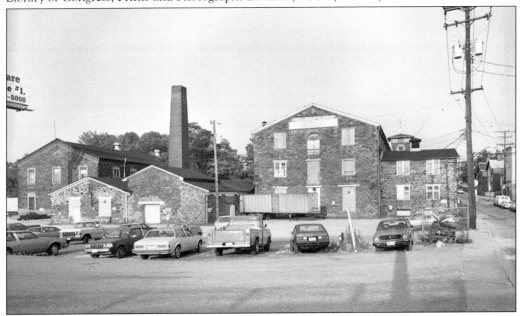

This photograph of Druid Mill shows the original mill building constructed in 1866 on the right and the addition constructed in 1872 on the left. Upon construction of this addition, Druid Mill was the largest mill producing cotton duck fabric in the world. (Courtesy of the Library of Congress, Prints and Photographs Division, HABS/HAER.)

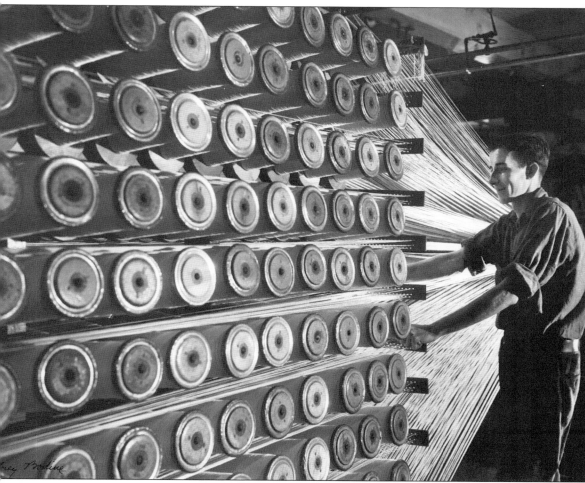

This image from the 1950s shows a worker feeding the individual yarns into the large, complex looms that produced large quantities of fabric. After becoming a center for producing cloth, especially cotton duck, in the 19th and early 20th centuries, most mills converted to the production of synthetics by mid-century before ultimately closing within a few years. (Photograph by A. Aubrey Bodine, copyright Jennifer B. Bodine.)

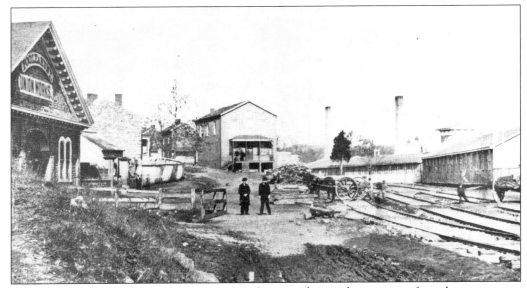

Founded in 1853, Poole and Hunt Iron Works manufactured a variety of machinery, steam engines, screw-pile lighthouses, and other miscellaneous iron works. In this mid-19th century photograph, the first shop for the Poole and Hunt Iron Works is visible on the left, while the Park Mill, constructed in 1855 to manufacture twine for fishing nets, is visible across the railroad tracks on the right. (Courtesy of the Struever Brothers, Eccles, and Rouse, Inc.)

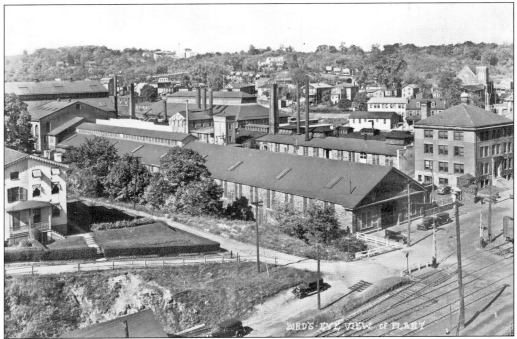

After 1920, the company failed, and the complex was taken over by the Balmar Corporation Foundry and Machine Works. In this aerial view, the Administration Building is visible to the far right, with the original erecting shop fronting the railroad tracks and the enormous foundry building beyond. (Courtesy of the Struever Brothers, Eccles, and Rouse, Inc.)

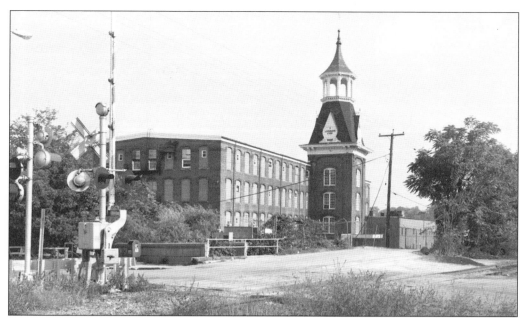

A familiar landmark to travelers on Interstate 83, the iconic tower of Meadow Mill was constructed in 1877 and produced textiles up until the 1960s. At that time, the mill was converted to produce rainwear for the London Fog Company. London Fog moved their production lines out after a quarter-century, and since that time, the mill has served a mixture of tenants including office tenants, a pottery studio, and an athletic club. (Courtesy of the Library of Congress, Prints and Photographs Division, HABS/HAER.)

Mount Vernon Mill was the last textile mill to cease production in Baltimore, finally closing in 1973. Mill Number 1, shown here, was converted from the water-powered Laurel Flour Mill in 1845. The mill was severely damaged by fire in 1873 while undergoing expansion. (Courtesy of the Library of Congress, Prints and Photographs Division, HABS/HAER.)

Mount Vernon Mill Number 2 also remains standing and has served a variety of storage and light manufacturing uses after the mill closed. Mill Number 2 was originally built to make use of steam power. A number of supporting outbuildings are also visible in this picture. (Courtesy of the Library of Congress, Prints and Photographs Division, HABS/HAER.)

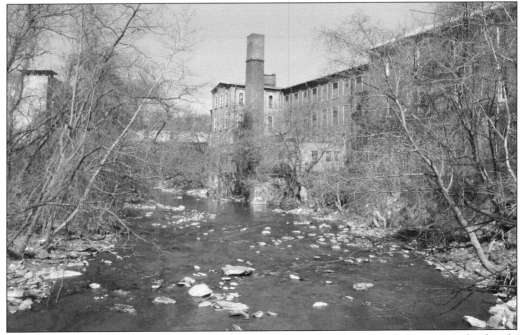

Mount Vernon Mill remains remarkably intact to this day, with minimal changes to the facade facing the Jones Falls. (Courtesy of the author.)

Two

THE PORT

Baltimore came to be because of its favorable placement on the Chesapeake Bay, well inland of the Atlantic Ocean but still with deepwater access for oceangoing vessels. Because of the port, Baltimore has always had a greater sense of connection to the world at large than some other industrial cities. Raw materials from around the world to feed Baltimore's growing industrial base were shipped into the port, while coal, tobacco, and other valuable commodities were exported.

The port of Baltimore was also a major point of entry for immigrants to this country before Ellis Island opened in New York. Over two million immigrants arrived through the port of Baltimore, approximately half of them entering through the Baltimore and Ohio Railroad's Locust Point immigration piers. The specific requirements for piers, bulkheads, rail sidings, and other supporting infrastructure has had as great an influence on the actual form of the harbor and shoreline as any other element that has helped mold the layout of Baltimore.

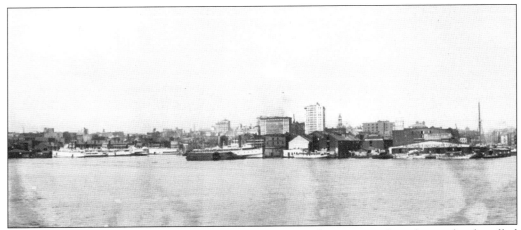

The Inner Harbor was ringed with a large number of steamboat terminals and piers that handled all manner of bulk cargo. This photograph from 1904 highlights the ramshackle nature of pier construction prior to the great Baltimore fire. (Courtesy of the Library of Congress, Prints and Photographs Division.)

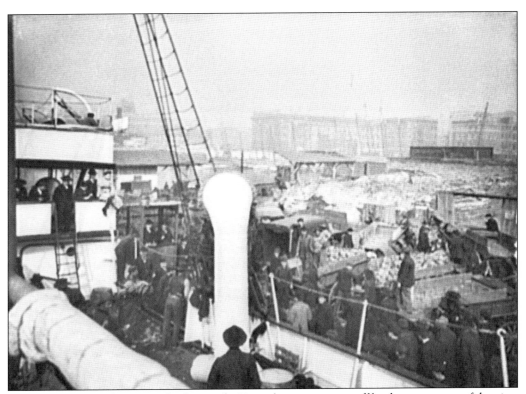

Baltimore was a regular stop in the fruit trade. Here a banana steamer off-loads cargo at one of the piers in the harbor. United Fruit maintained a large pier complex on Pratt Street. (Courtesy of the Library of Congress, Prints and Photographs Division, Detroit Publishing Company Collection.)

Baltimore was also a major point of entry for imported fruit, with several piers around the harbor dedicated to the warehousing and distribution of fruits around the world, especially Central and South America. Longshoremen hauled the loads of produce from the bulk cargo ships to the warehouses for eventual shipment around town and around the country. (Photograph by A. Aubrey Bodine, copyright Jennifer B. Bodine.)

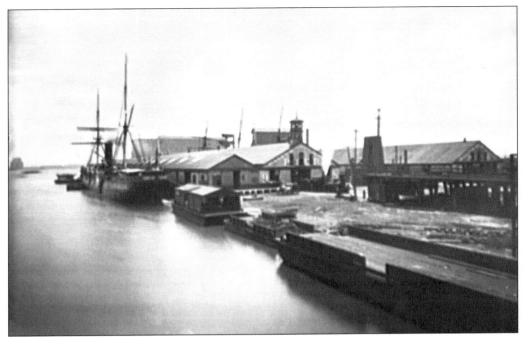

The immigration pier in Locust Point was one of the primary immigration gateways to America before New York's Ellis Island was established. (Courtesy of the Library of Congress, Prints and Photographs Division, Detroit Publishing Company Collection.)

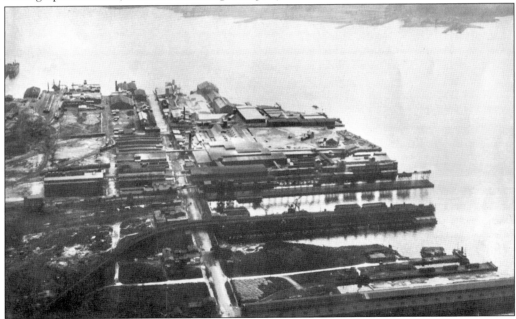

Lazaretto Point, located on the eastern shore of the southwest branch of the Patapsco River, has been the site of several materials processing plants, capitalizing on the site's proximity to the deepwater access necessary for large cargo ships. (Courtesy of the Baltimore City Commission for Historical and Architectural Preservation [CHAP].)

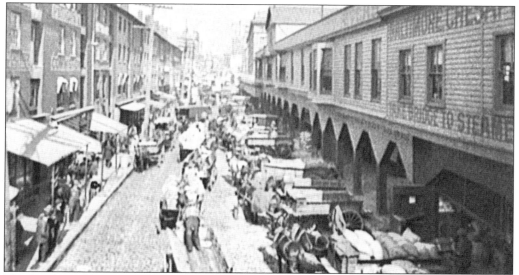

The hustle and bustle of Baltimore's waterfront are evident in this photograph of Light Street from 1906. The steamboat terminals on the right were eventually removed, and McCormick and Company would erect their nine-story factory and headquarters building on the left-hand side of the street. (Courtesy of the Library of Congress, Prints and Photographs Division, Detroit Publishing Company Collection.)

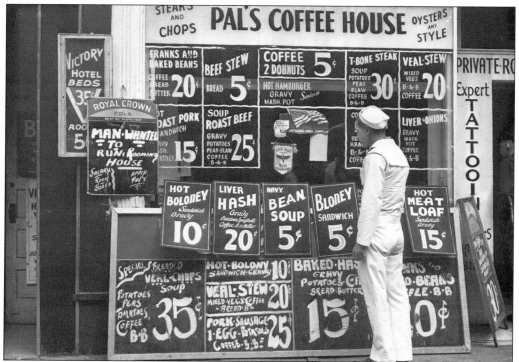

Baltimore was home to a large transient population of sailors. Pal's Coffeeshop served up breakfast and lunch for years from its location near the harbor. (Photograph by A. Aubrey Bodine, copyright Jennifer B. Bodine.)

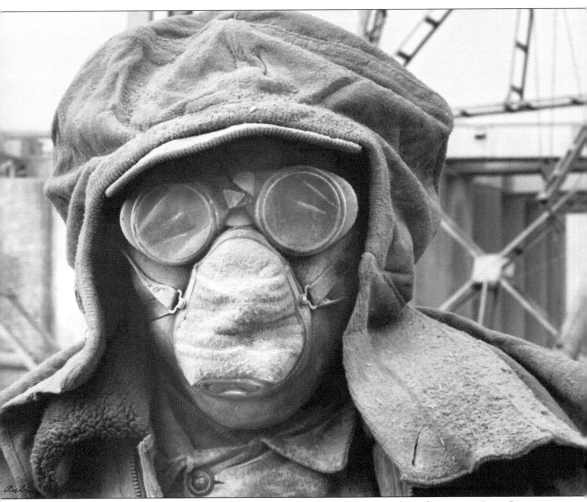

Work at the ports was frequently dirty and difficult. Workers, such at this one at Port Covington, needed to take precautions to protect themselves against the elements and the cargo they were handling. (Photograph by A. Aubrey Bodine, copyright Jennifer B. Bodine.)

Three

THE RAILROAD

The railroads have in many ways had a more profound influence on Baltimore's appearance than any other single factor. From the first 13-mile length of railroad in the United States between Mount Clare Station and Ellicott's Mills, the Baltimore and Ohio Railroad reached across the country to link Baltimore to cities throughout the heartland. Between the rail right-of-ways, magnificent passenger stations, large warehouses and freight depots, extensive marshaling yards, and enormous pier facilities, the railroads have undoubtedly altered more area in Baltimore than any other industry.

Linking the port to hinterlands, the railroads provided a vital conduit for goods and people and also provided employment for a large number of workers in town. The Baltimore and Ohio Railroad's vast Mount Clare complex supported the surrounding neighborhood, employing thousands of workers in all aspects of work from constructing and repairing locomotives and rolling stock to fabricating bridges for the vast rail network. Other railroads with a significant presence in Baltimore included the Western Maryland Railroad, Pennsylvania Railroad, Northern Central Railroad, and the Maryland and Pennsylvania Railroad (known as the Ma and Pa). All of these railroads maintained facilities and employed thousands of workers at a variety of stations, warehouses, switching yards, and piers.

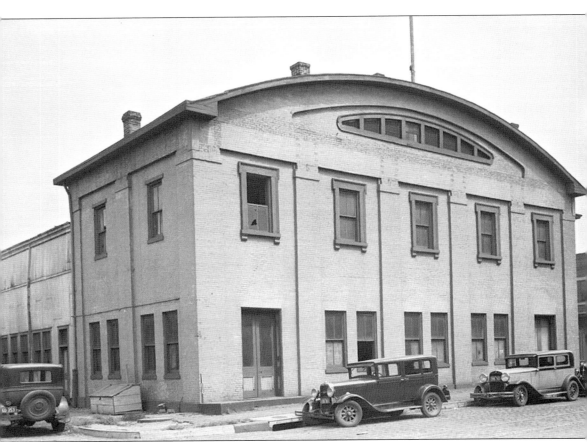

As the oldest passenger station in Baltimore, the President Street Station has seen its share of history. On April 19, 1861, Union troops marching from President Street Station to Camden Station were set upon by Southern sympathizers in one of the first skirmishes of the Civil War. (Courtesy of the Library of Congress, Prints and Photographs Division, HABS/HAER.)

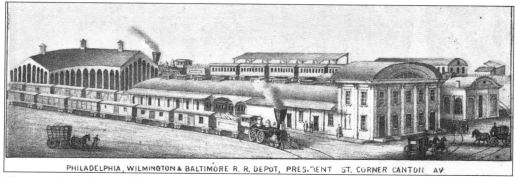

PHILADELPHIA, WILMINGTON & BALTIMORE R. R. DEPOT, PRESIDENT ST. CORNER CANTON AV.

This artist's rendering of the President Street Station illustrates the station in its heyday, c. 1870. Note the size of the elongated train shed in relation to the relatively diminutive head house. (Courtesy of the Library of Congress, Geography and Map Division.)

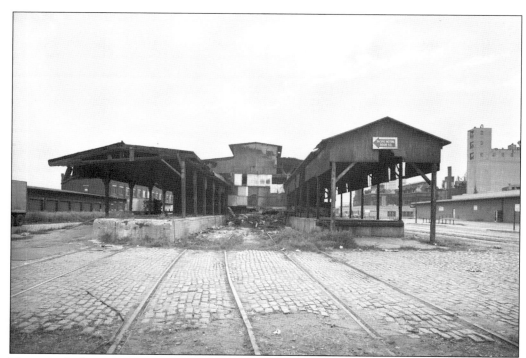

The train shed, pictured here, measured over 200 feet in length, extending east from President Street. The train shed has been demolished, and this area is now part of the Inner Harbor redevelopment. (Courtesy of the Library of Congress, Prints and Photographs Division, HABS/HAER.)

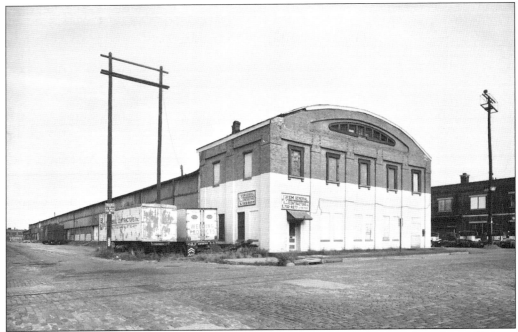

Built for the Philadelphia, Wilmington and Baltimore Railroad, the President Street Station served as a passenger station for only a few decades before its conversion to freight handling. It then fell into very poor condition prior to its restoration in the 1990s. (Courtesy of the Library of Congress, Prints and Photographs Division, HABS/HAER.)

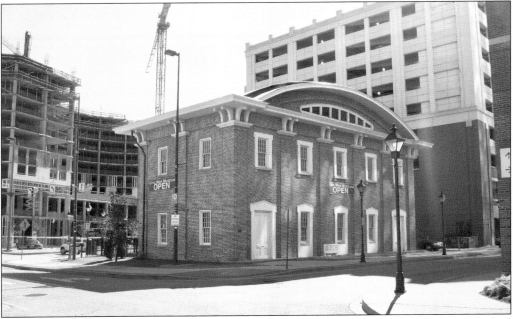

The President Street Station now serves as Baltimore's Civil War Museum. With the train shed demolished, the head house is now surrounded and dwarfed by new development. (Courtesy of the author.)

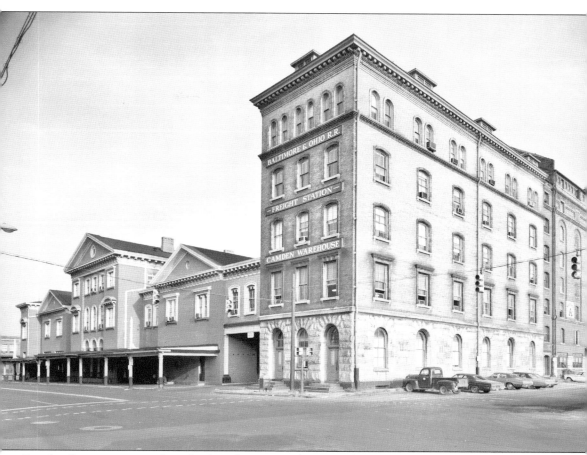

Camden Station was significantly altered over time, losing its distinctive cupolas and gaining an office tower on the west side. Built in 1905, the eight-story office tower connected back to the Camden warehouse beyond. The office tower was demolished, and the west wing of Camden Station was restored as part of the redevelopment of Oriole Park at Camden Yards in the early 1990s. The station remained in continuous service for long-distance passengers until 1971, and Maryland Rail Commuter (MARC) passengers used the station until 1986. When service was finally discontinued, Camden Station was the oldest continuously operating train station in the United States. (Courtesy of the Library of Congress, Prints and Photographs Division, HABS/HAER.)

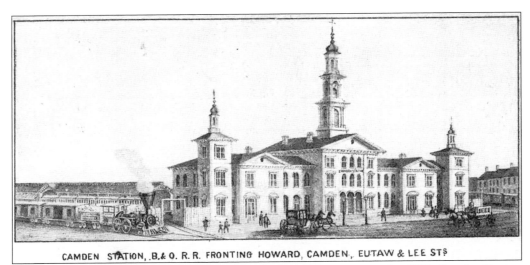

CAMDEN STATION, B.& O. R.R. FRONTING HOWARD, CAMDEN, EUTAW & LEE STS

With the center bay constructed in 1857 and the flanking bays constructed in 1865, Camden Station was the first permanent passenger station in Baltimore for the Baltimore and Ohio Railroad. This rendering from 1870 illustrates the station, designed by Neirnsee and Nielson, prior to significant alterations. (Courtesy of the Library of Congress, Geography and Map Division.)

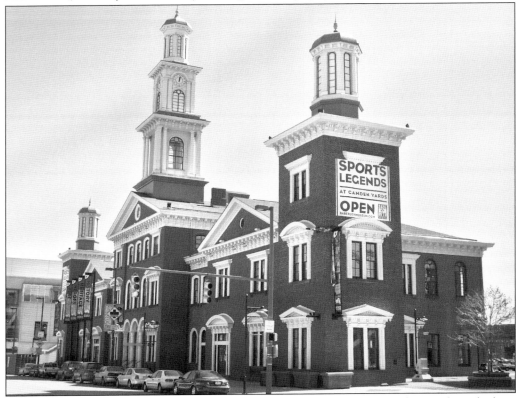

The Baltimore and Ohio Railroad's Camden Station continues to play a significant role in the lives of Baltimoreans to this day, serving as a sports museum and gateway to Oriole Park at Camden Yards. (Courtesy of the author.)

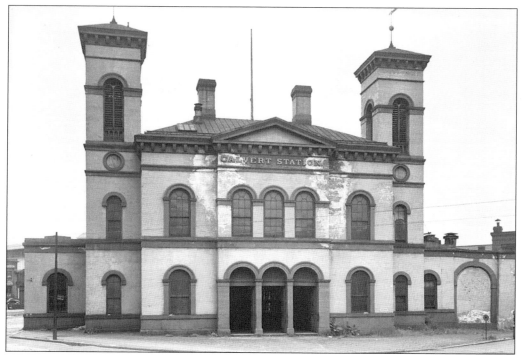

Neirnsee and Nielson designed the Calvert Station in 1849–1850 for the Baltimore and Susquehanna Railroad. The Italianate station was designed to handle both passengers and freight and also housed the company's offices. (Courtesy of the Library of Congress, Prints and Photographs Division, HABS/HAER.)

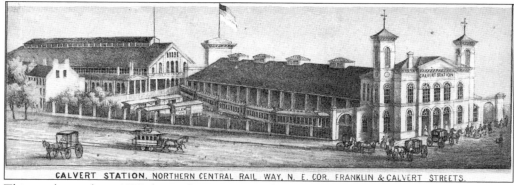

This rendering from 1870 shows the entire complex of the Northern Central Railway (as the reorganized Baltimore and Susquehanna was named). The passenger station, train shed, and freight terminal are all clearly visible. (Courtesy of the Library of Congress, Geography and Map Division.)

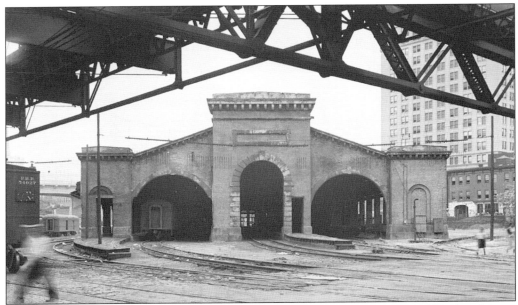

The Calvert Station train shed featured an iron roof bearing on granite and brick columns. (Courtesy of the Library of Congress, Prints and Photographs Division, HABS/HAER.)

This photograph from 1930 shows the Calvert Station and train shed in the middle of the image with the freight terminal beyond. While the freight terminal remains today, the passenger station and train shed were demolished in 1948 to make way for the *Baltimore Sun* headquarters. (Courtesy of the Enoch Pratt Free Library, Central Library/State Library Resource Center, Baltimore, Maryland.)

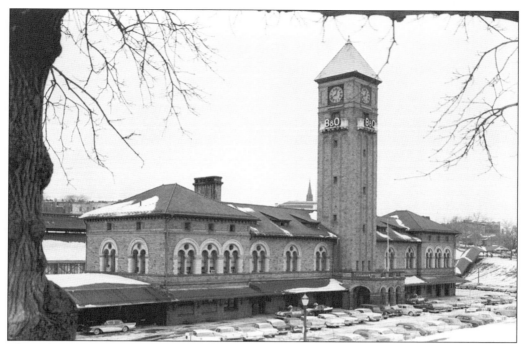

The Baltimore and Ohio Railroad's Mount Royal Station was designed by E. Francis Baldwin and features a 143-foot-high clock tower. The station provided service to the northern suburbs until closing in 1961. (Courtesy of the Library of Congress, Prints and Photographs Division, HABS/HAER.)

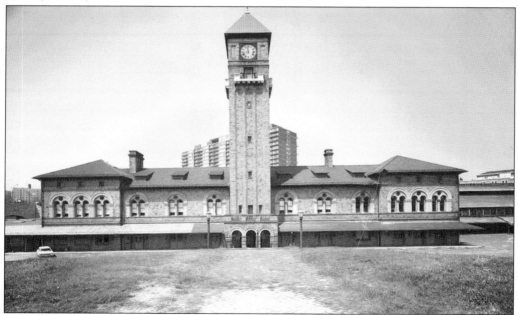

Today the train station and passenger sheds have been successfully adapted for studio space by the Maryland Institute College of Art. (Courtesy of the Library of Congress, Prints and Photographs Division, HABS/HAER.)

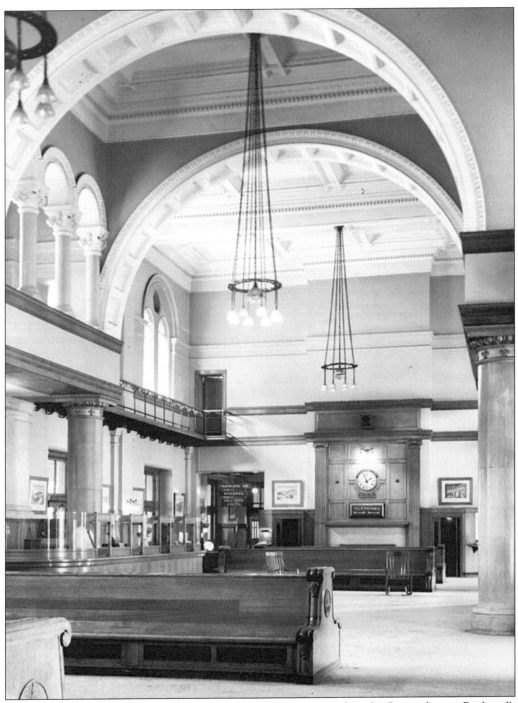

Mount Royal Station was known for its quieter pace, compared to the Pennsylvania Railroad's station several blocks away. The grand interior pictured here, coupled with legendary rocking chairs located on the outdoor portico, led to a feeling of unhurried gentility at this station. (Courtesy of the Library of Congress, Prints and Photographs Division, HABS/HAER.)

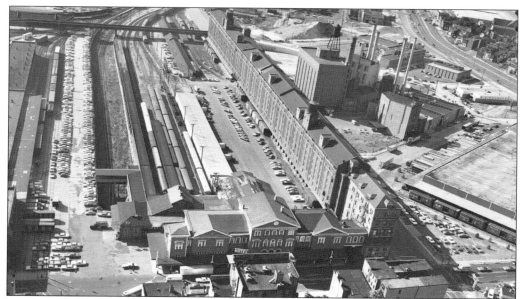

Camden Warehouse was constructed in phases between 1899 and 1904 to handle freight for the Baltimore and Ohio Railroad (B&O), including specialized facilities for handling inbound fruits and vegetables for transfer to Baltimore's wholesale produce district just east of Camden Station. Designed by E. Francis Baldwin, the B&O architect of choice for many years, and three blocks in length, Camden Warehouse was reputed to be the longest brick building in the world. (Courtesy of the Library of Congress, Prints and Photographs Division.)

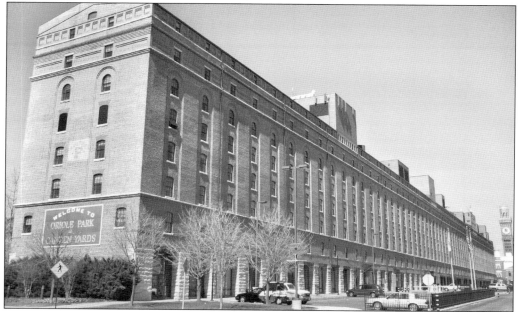

Camden Warehouse was spared demolition when the Maryland Stadium Authority opted to include the warehouse in the design of the new ballpark for the Baltimore Orioles. Containing retail establishments and restaurants on the ground level with office space on the floors above, the renovated warehouse is an integral part of Oriole Park at Camden Yards. (Courtesy of the author.)

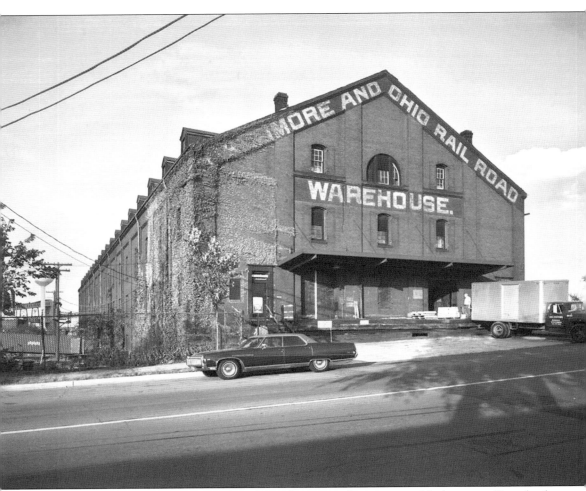

The B&O was the dominant railroad in Baltimore and was responsible for controlling the form and type of development for large sections of the city. The B&O's Locust Point terminal was the largest cargo handling facility on the harbor, fundamentally dictating the form of the peninsula and the piers that were served by the rail lines. This striking facility was originally built to warehouse tobacco for shipment to Europe and later stored wood pulp, toys, and rubber. (Courtesy of the Library of Congress, Prints and Photographs Division, HABS/HAER.)

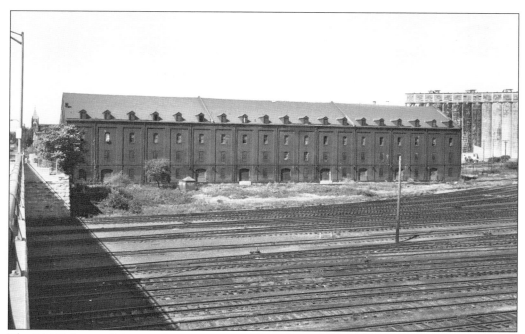

The B&O's Locust Point warehouse was served by rail lines on both the east and west sides of the building. (Courtesy of the Library of Congress, Prints and Photographs Division, HABS/HAER.)

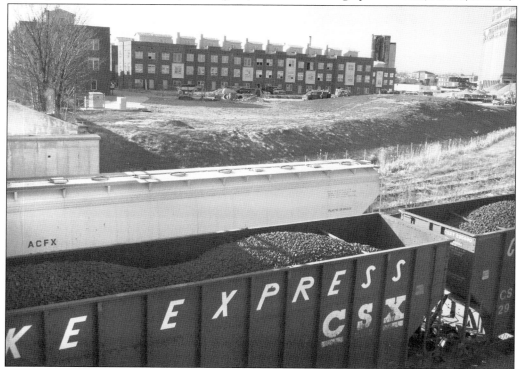

The Locust Point warehouse was demolished in the late 1990s and has since been redeveloped as part of the Silo Point development. (Courtesy of the author.)

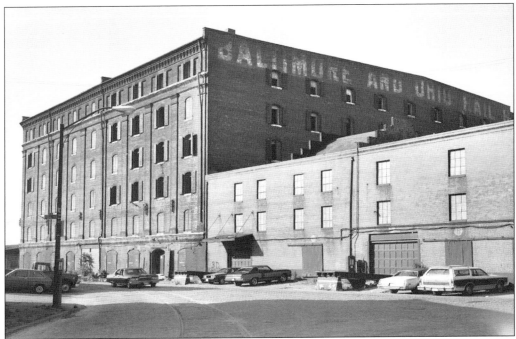

The B&O also had a second tobacco warehouse located on the opposite side of the harbor from Locust Point in Fells Point. This structure has subsequently been successfully redeveloped into apartments and condominiums. (Courtesy of the Library of Congress, Prints and Photographs Division, HABS/HAER.)

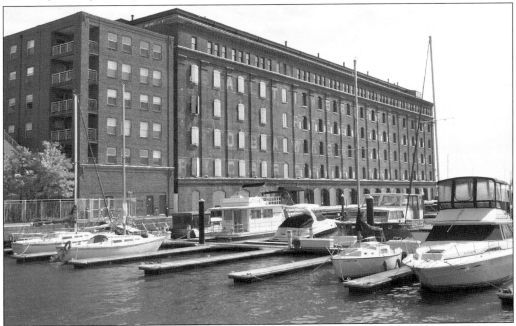

Today Fells Point, the waterfront former industrial neighborhood, is now one of the most desirable locations in Baltimore City. (Courtesy of the author.)

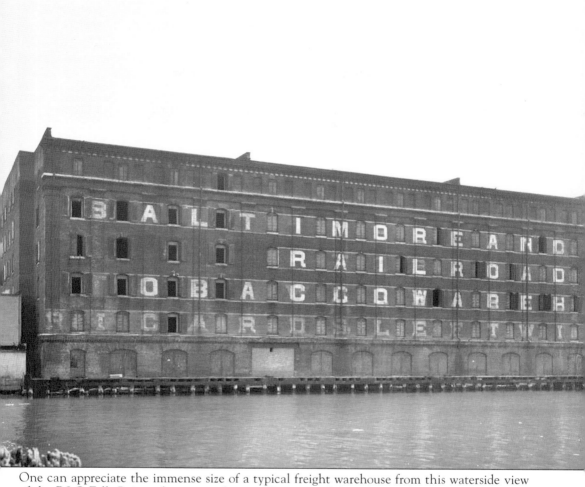

One can appreciate the immense size of a typical freight warehouse from this waterside view of the B&O Fells Point tobacco warehouse. (Courtesy of the Library of Congress, Prints and Photographs Division, HABS/HAER.)

Warehouses were critical for storing products heading into and out of Baltimore harbor. Each railroad serving the city had a variety of specialty warehouses for storing differing cargo. Here is the Northern Central Railway's freight station on Guilford Avenue. (Courtesy of the Library of Congress, Prints and Photographs Division, HABS/HAER.)

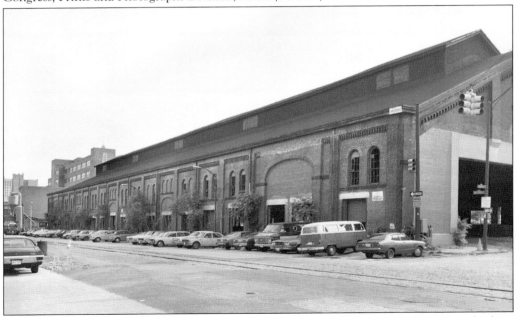

After the Calvert Station and train shed were demolished in 1948, the freight station, built in 1865, was remodeled to handle passengers until the station closed in 1959. (Courtesy of the Library of Congress, Prints and Photographs Division, HABS/HAER.)

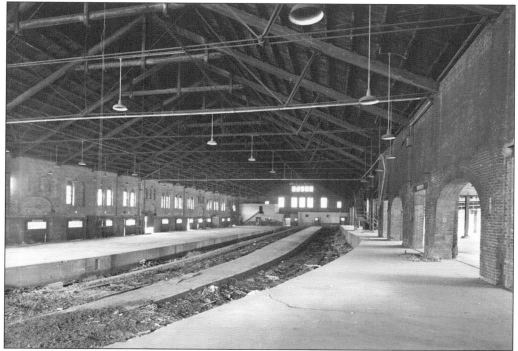

The Northern Central Railway freight station was converted a while ago into an athletic club, making use of the long, clear, high-bay span of space contained within. (Courtesy of the Library of Congress, Prints and Photographs Division, HABS/HAER.)

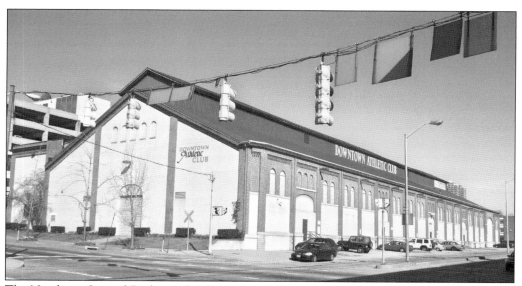

The Northern Central Railway's freight station still stands, serving for quite some time now as an athletic club. (Courtesy of the author.)

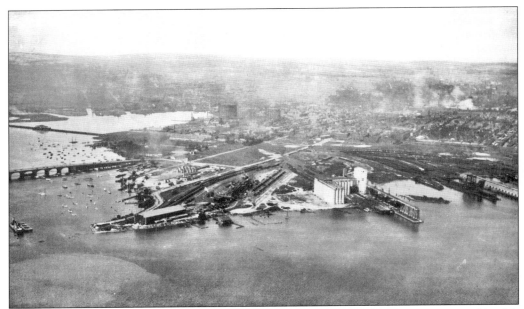

This aerial view of Port Covington from the 1920s illustrates how much area was consumed by this large port facility. Originally constructed on the south side of Locust Point by the Western Maryland Railroad to provide ocean access for Appalachian coal, the pier complex expanded to also handle lumber, grain, and a variety of other products. (Courtesy of the Baltimore City CHAP.)

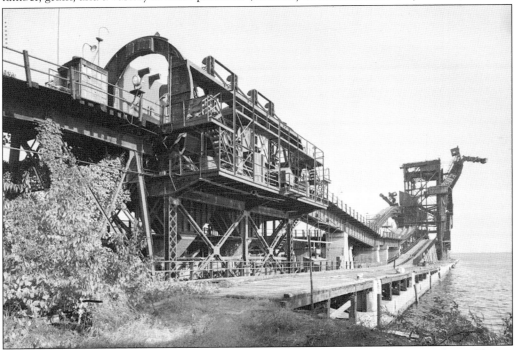

This view of the Port Covington Coal Pier shows the complex series of ramps, rails, and hoists used to transfer coal from train cars to oceangoing freighters. (Courtesy of the Library of Congress, Prints and Photographs Division, HABS/HAER.)

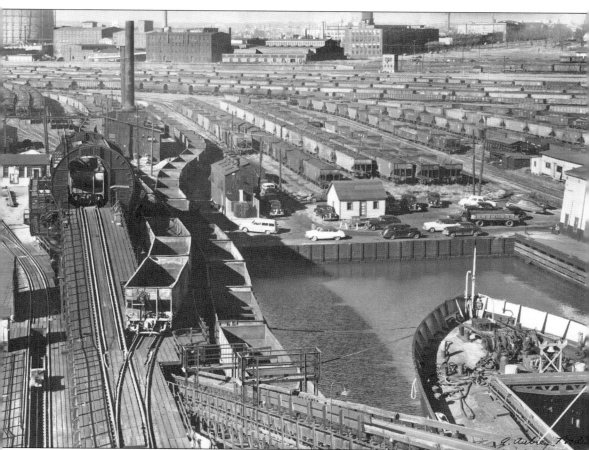

This view from the top of the Port Covington Coal Pier also highlights the vast switching yard used by the B&O Railroad. Much of the area visible in the mid-ground is now occupied by the *Baltimore Sun* printing plant and the right-of-way for Interstate 95. Riverside Park and the buildings of South Baltimore are visible in the background. (Photograph by A. Aubrey Bodine, copyright Jennifer B. Bodine.)

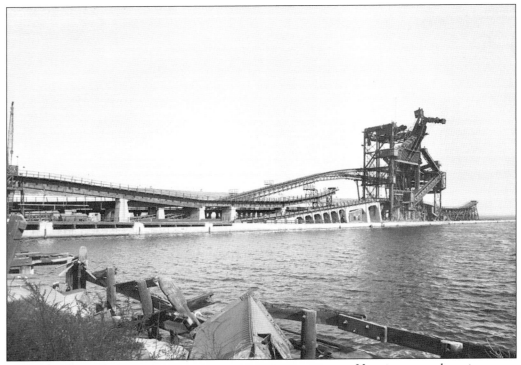

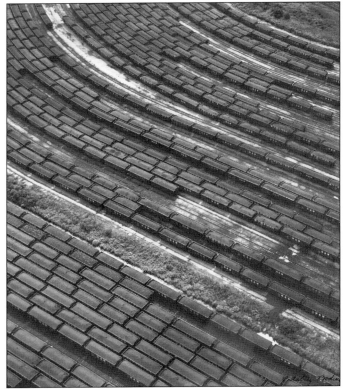

Here is yet another view of the "roller coaster" of track necessary to transfer coal from trains to ships. (Courtesy of the Library of Congress, Prints and Photographs Division, HABS/HAER.)

This aerial view of the railroad marshaling yards illustrates the vast quantities of coal that were shipped from Western Maryland through the port of Baltimore and out the Chesapeake Bay to ports across the country and around the world. (Photograph by A. Aubrey Bodine, copyright Jennifer B. Bodine.)

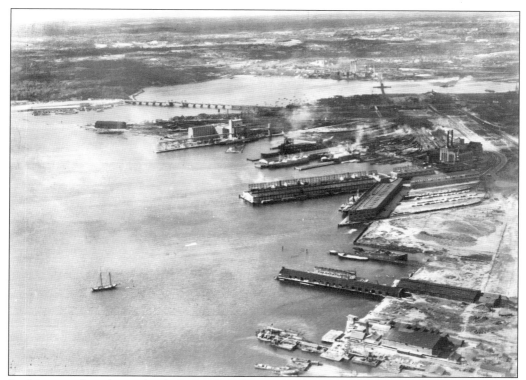

In this view, the relationship between Port Covington (center), the Gould Street Power Station (on the right), and the Hanover Street Bridge beyond are clearly visible. (Courtesy of the Library of Congress, Prints and Photographs Division.)

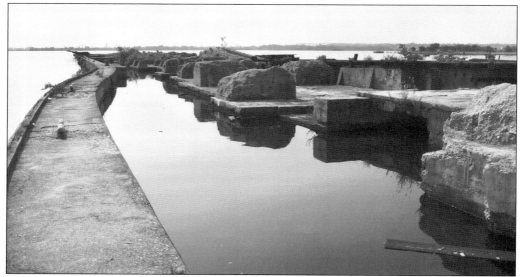

The Port Covington site was cleared in 1989 to provide a new site for the *Baltimore Sun*'s printing plant and to provide an additional area for development in the city. All of the elaborate superstructure associated with the coal pier has been removed. All that remains today are the concrete foundations that supported the superstructure. (Courtesy of the author.)

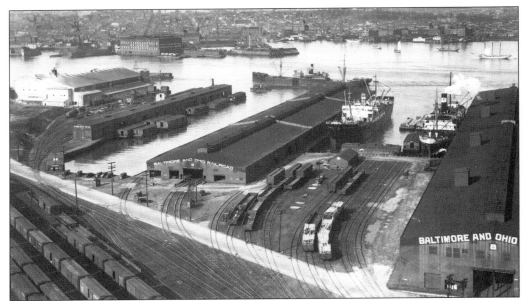

The B&O maintained a large sequence of piers on the north shore of Locust Point. In addition to shipping and receiving materials at this location, Locust Point was also a major port of entry for immigrants traveling to America. (Courtesy of the Enoch Pratt Free Library, Central Library/State Library Resource Center, Baltimore, Maryland.)

Today Locust Point still carries a substantial amount of rail traffic to the port terminals, handling a wide variety of bulk cargo as well as finished products such as automobiles. (Courtesy of the author.)

One of the more interesting adaptive-use projects currently underway is the conversion of an abandoned grain pier and silo complex into market rate housing, known as Silo Point. (Courtesy of the author.)

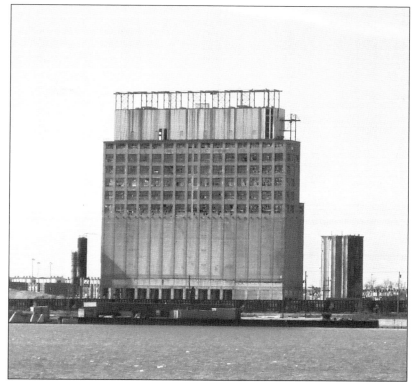

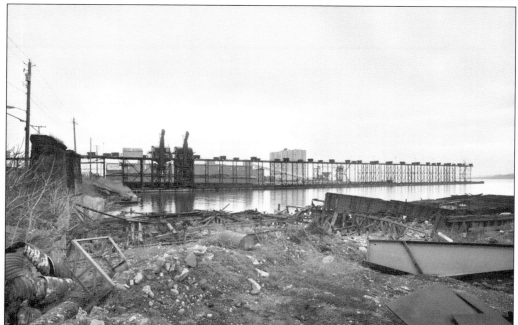

As the B&O exerted substantial control over Locust Point, so the Pennsylvania Railroad did in Canton. Canton's coal piers were a significant presence on the Inner Harbor for a long time. (Courtesy of the Library of Congress, Prints and Photographs Division, HABS/HAER.)

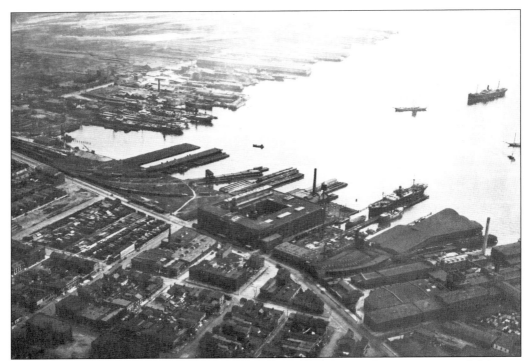

This aerial view of Boston Street in Canton effectively conveys what percentage of this area was dedicated to pierage. The large building in the center of the picture is the Tin Decorating Company (Tindeco). (Courtesy of the Baltimore City CHAP.)

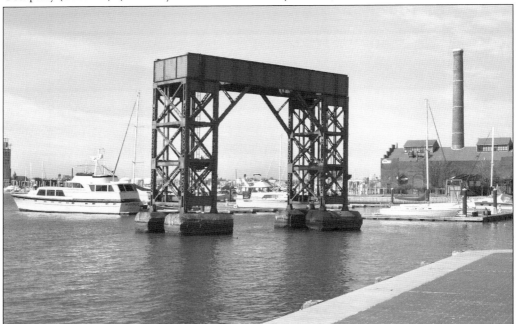

This large steel structure bearing on concrete piers is the lone artifact remaining from the pier that once stood here, east of the Tin Decorating Company. (Courtesy of the author.)

The equipment used to transfer coal to ships traveled along the Canton coal pier on rails. The conveyor booms were lowered to provide a path from the coal cars to the waiting cargo ships. (Courtesy of the Library of Congress, Prints and Photographs Division, HABS/HAER.)

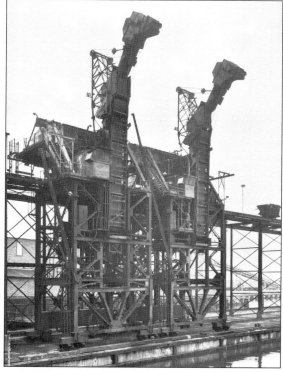

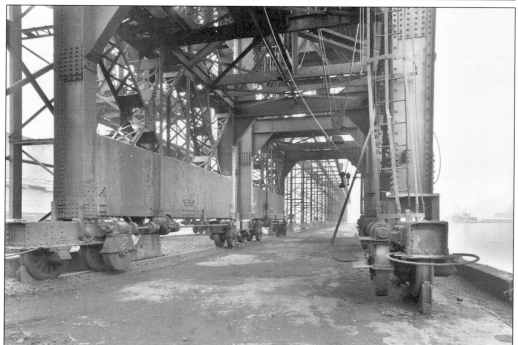

A ground-level view shows how the Canton Coal Pier equipment moved on rails. (Courtesy of the Library of Congress, Prints and Photographs Division, HABS/HAER.)

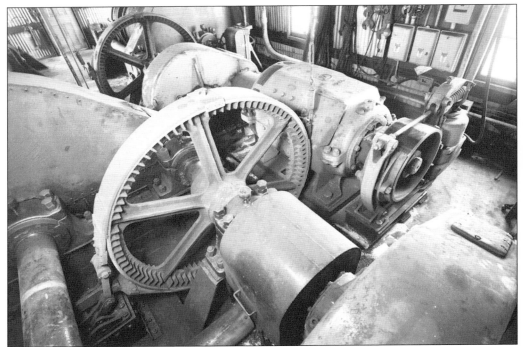

Large engines were used to power the Coal Pier equipment. (Courtesy of the Library of Congress, Prints and Photographs Division, HABS/HAER.)

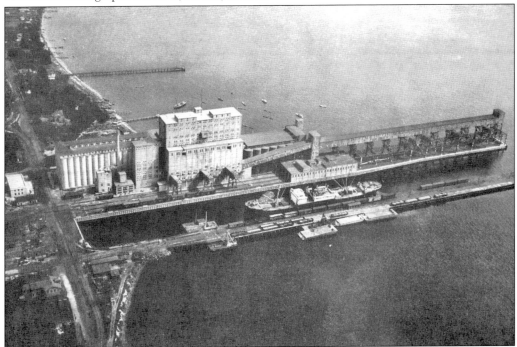

This is another large terminal in Canton controlled by the Pennsylvania Railroad father east on Boston Street. (Courtesy of the Baltimore City CHAP.)

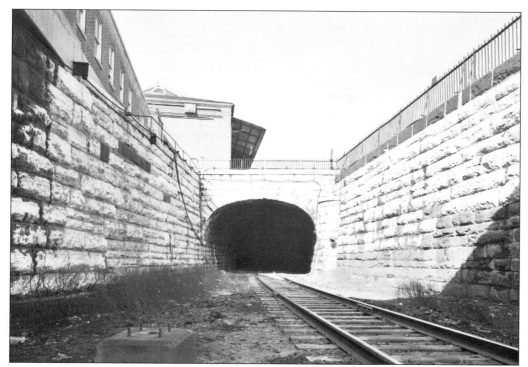

The Howard Street Tunnel was constructed in 1895 to connect the B&O Railroad's southern lines with its new line to Philadelphia by routing a 7,341-foot-long tunnel underneath Howard Street between Camden Station and Mount Royal Station. A significant innovation was the installation of the world's first main-line electrified railway to eliminate gas and fumes associated with coal-burning locomotives from the tunnel. The tunnel received a great deal of notoriety in July 2001, when a fire in the tunnel consumed a series of freight cars, shutting down portions of Baltimore's Westside neighborhood for several days and leading indirectly, through damaging a large water main, to several street collapses. (Courtesy of the Library of Congress, Prints and Photographs Division, HABS/HAER.)

This locomotive roundhouse was constructed for the Maryland and Pennsylvania (Ma and Pa) Railroad in 1910. After closing in 1958, this simple stone structure was purchased by the city and currently stores salt for the winter driving season. (Courtesy of the author.)

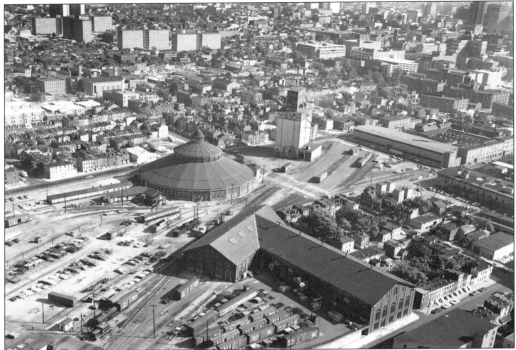

This aerial view illustrates the vast scale of the Mount Clare complex. At its peak, the Mount Clare complex served as the primary construction and repair facility for the B&O Railroad. Not only were locomotives, freight cars, and passenger cars constructed at this facility, but also repairs to cars and locomotives were completed, bridges for B&O lines were fabricated, and it even had a print shop to handle a wide variety of needs for the company. (Courtesy of the Library of Congress, Prints and Photographs Division, HABS/HAER.)

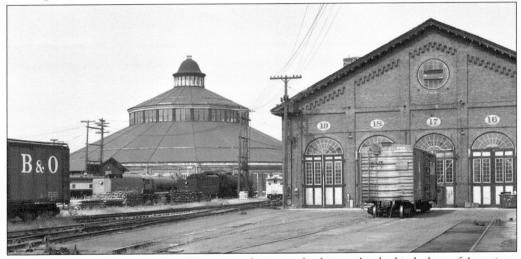

The B&O Railroad's Mount Clare Station can legitimately claim to be the birthplace of American railroading, for it was from this location that the first 13 miles of track were laid to Ellicott's Mills, establishing the country's first regularly scheduled passenger rail service. (Courtesy of the Library of Congress, Prints and Photographs Division, HABS/HAER.)

This two-story octagonal building is frequently mistakenly identified as the original station, dating to 1830. In fact, this station dates to 1850 and was built to serve the neighborhood surrounding the Mount Clare works. (Courtesy of the Library of Congress, Prints and Photographs Division, HABS/HAER.)

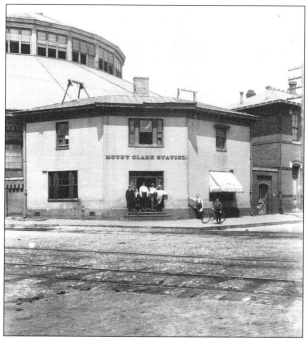

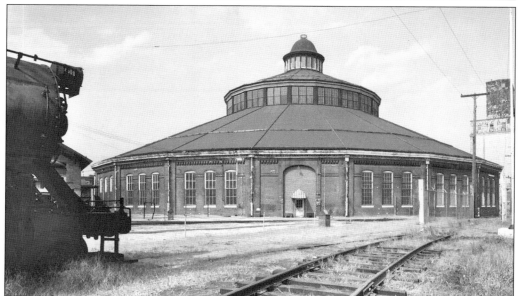

The largest and most distinctive building at Mount Clare is the gold-domed passenger car shop, constructed in 1883. Designed by E. Francis Baldwin, this facility housed the building and repairing of the B&O's passenger cars until the building was converted to a museum in 1953. Tragedy struck on the night of February 16, 2003, when a design flaw in the roof structure that had gone undetected for over a century caused the roof to collapse during a snowstorm. Both the building and the historic trains contained inside were severely damaged. The roundhouse has now been rebuilt, and efforts are ongoing to restore the damaged locomotives and passenger cars. (Courtesy of the Library of Congress, Prints and Photographs Division, HABS/HAER.)

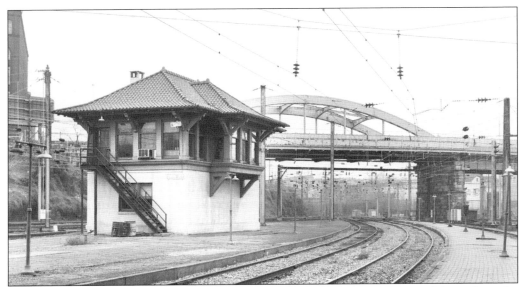

Railroads also required many small outbuildings to keep things running smoothly, such as the Union Junction Interlock Tower, pictured here. This particular interlock tower was demolished during a recent track realignment to accommodate light rail service to Pennsylvania Station. (Courtesy of the Library of Congress, Prints and Photographs Division, HABS/HAER.)

Before modern, computer-controlled switching, these interlock towers kept trains running on the right tracks and ensured that two trains wouldn't end up on the same track section traveling in opposite directions. (Courtesy of the Library of Congress, Prints and Photographs Division, HABS/HAER.)

Four

HEAVY INDUSTRY

Heavy industries made use of Baltimore's location to access raw materials from around the world to manufacture a variety of products and then in turn distribute those products around the country and around the world.

Numerous blue-collar union jobs have been lost with the decline in Baltimore's heavy industries. Some of the city's largest employers, with payrolls of thousands, and tens of thousands, of people, have either drastically reduced their workforce or closed up shop for good. Sparrows Point was the largest steel mill in the country in 1971 and has seen employment decline from a peak of 35,000 to less than 10 percent of that figure. The shipyards, Western Electric's plant at Point Breeze, and General Motors' Broening Highway Assembly Plant have all gone by the wayside as well.

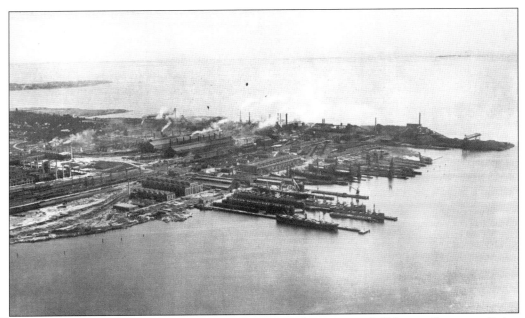

This aerial photograph from the 1920s illustrates the massive 2,500-acre Sparrows Point Steelworks and Shipyards. Visible in this photograph are the shipyard in the foreground, the ore docks in the background, and the massive steel-mill complex inland. (Courtesy of the Baltimore City CHAP.)

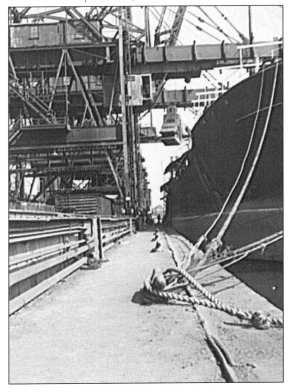

One of the large ore freighters is unloading the iron ore that will begin its process of conversion to steel at the Sparrows Point Mill. Raw materials were delivered in bulk via freighter and rail car, processed in the mills to create steel, and then milled into a variety of shapes and forms. Some of these elements were then immediately incorporated into the production of ships in the adjacent shipyards. (Courtesy of the Library of Congress, Prints and Photographs Division, Farm Security Administration-Office of War Information [FSA-OWI] Collection.)

This massive ore crane was used to transfer the raw iron ore from the freighters to the conveyors leading to the open-hearth furnaces. (Courtesy of the Library of Congress, Prints and Photographs Division, FSA-OWI Collection.)

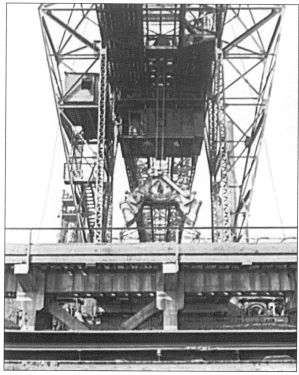

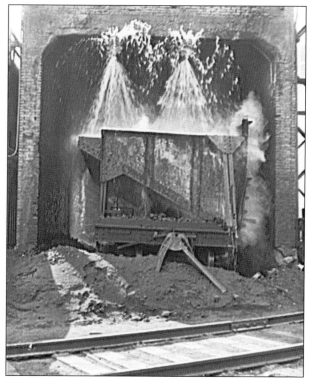

In this photograph, water is being poured over a hopper of hot ashes from the blast furnace at Sparrows Point. At one time, Sparrows Point was the largest fully integrated steel mill in the country. A fully integrated steel mill starts with the required raw materials (iron, coke, limestone, and so on) and handles all of the operations on site to produce a finished product such as steel coils, rails, or structural members. (Courtesy of the Library of Congress, Prints and Photographs Division, FSA-OWI Collection.)

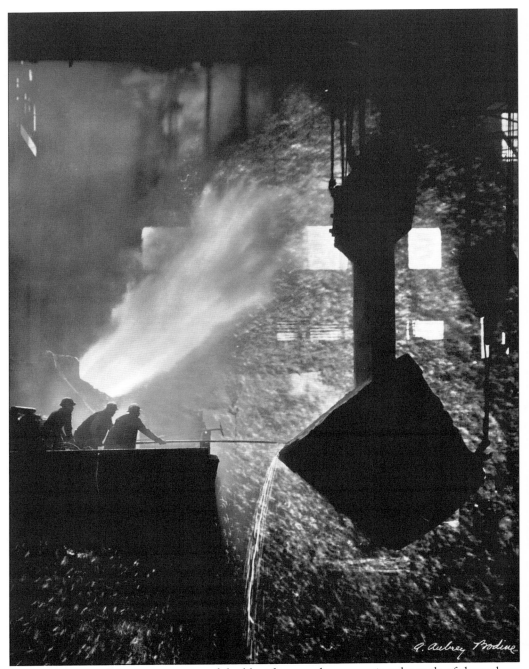

One gets a sense of the immense size of the blast furnaces by comparing the scale of these three workers to the ladle filled with molten steel they are attempting to maneuver. (Photograph by A. Aubrey Bodine, copyright Jennifer B. Bodine.)

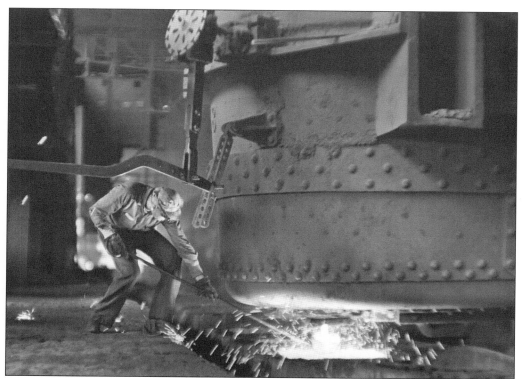

Working among the massive machinery was hot, dangerous, and strenuous. However, these union jobs paid well, and employment at the plant peaked at 35,000 in 1959. (Photograph by A. Aubrey Bodine, copyright Jennifer B. Bodine.)

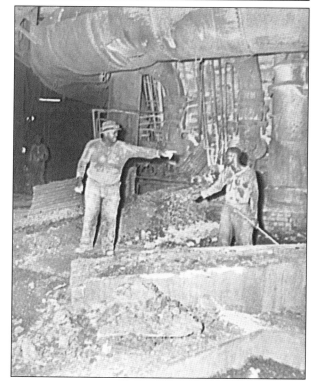

The mills' workforce was evenly split amongst immigrants, native-born whites, and African Americans. African Americans were frequently given the hottest, dirtiest, and most dangerous jobs in the mill. (Courtesy of the Library of Congress, Prints and Photographs Division.)

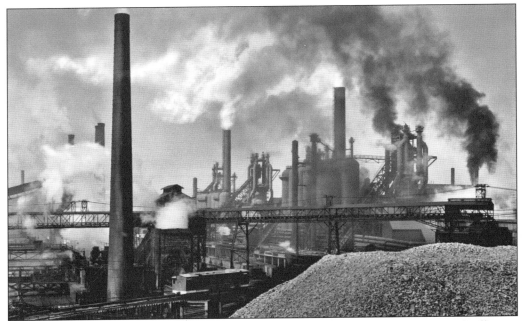

While Sparrows Point was a good source of jobs and steel, it was also a constant source of pollution. Workers referred to the fine red powder that settled over everything as "gold dust," as the dust represented the jobs and paychecks created by the steel mill. (Photograph by A. Aubrey Bodine, copyright Jennifer B. Bodine.)

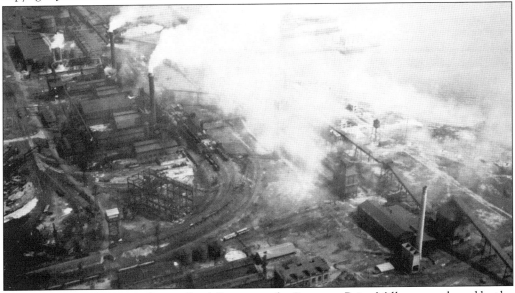

Built in 1893 for the Pennsylvania Steel Company, the Sparrows Point Mill was purchased by the Bethlehem Steel Company in 1916. Bethlehem continued to expand and modernize the mill's and shipyard's capacity throughout the 20th century until the collapse of the rust belt industries in the last quarter of the century. The mill was sold in 2005 to the Mittal Steel Company, which continues to operate this fully integrated steel mill. This image from the 1920s shows the mill in its heyday. (Courtesy of the Baltimore City CHAP.)

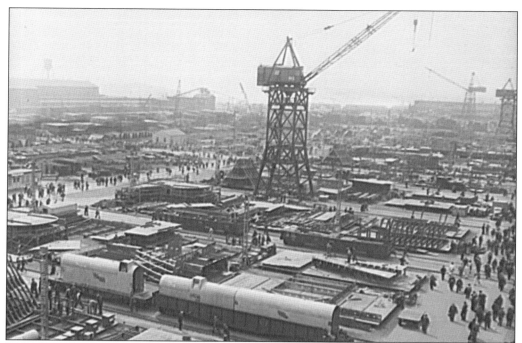

Bethlehem Steel Corporation at one point operated four shipyards in Baltimore. Two of the yards, Key Highway and Fort McHenry, focused on repair work, while the two other yards, Fairfield and Sparrows Point, concentrated on building new ships. The Fairfield Yard exploded in size and capacity during World War II at the request of the government. (Courtesy of the Library of Congress, Prints and Photographs Division, FSA-OWI Collection.)

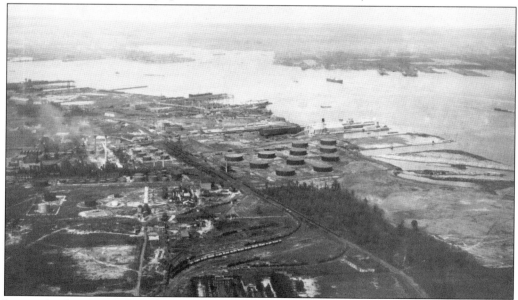

It is at this location, relatively empty in this view of Fairfield from the 1920s, that the Fairfield Shipyards will be constructed as part of the industrial effort of World War II. (Courtesy of the Baltimore City CHAP.)

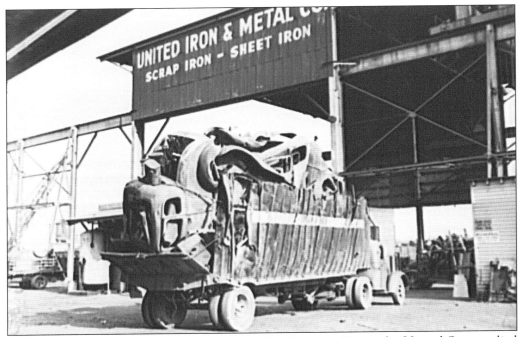

In addition to producing new steel at plants like Sparrows Point, the United States relied heavily on recycling scrap iron and steel during World War II. Automobiles were stripped of all usable parts and non-ferrous materials and then shipped to a scrap yard, where the iron and steel would be baled using large hydraulic presses and shipped to steel mills to be melted down to make more steel. (Courtesy of the Library of Congress, Prints and Photographs Division, FSA-OWI Collection.)

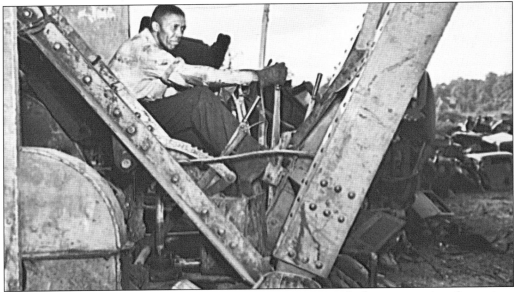

Here a worker operates a large electromagnetic crane to process the large quantities of scrap iron and steel destined for recycling at the Sparrows Point Mills. (Courtesy of the Library of Congress, Prints and Photographs Division, FSA-OWI Collection.)

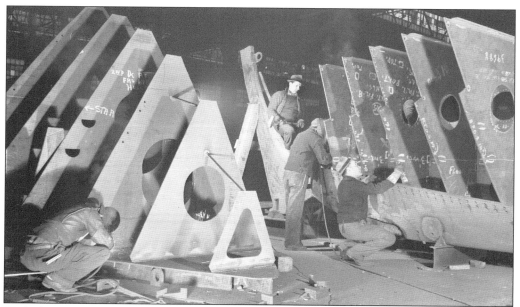

With the growing need to rapidly construct ships during World War II, a number of innovations were incorporated to speed the process. Baltimore's Fairfield Shipyard was able to reduce the amount of time required to build a Liberty ship from an average of 244 days to less than 30 days. One key innovation was fabricating entire assemblies away from the shipyard. The Fairfield Shipyard, owned by Bethlehem Steel, located one of their fabricating plants in a facility that formerly manufactured railroad cars. (Courtesy of the Library of Congress, Prints and Photographs Division, FSA-OWI Collection.)

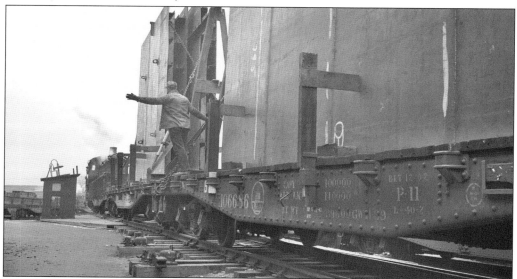

The prefabricated assemblies are loaded on flatcars for the six-mile journey to the shipyard. On September 27, 1941, the nation's first Liberty ship, the *Patrick Henry*, was launched from the Bethlehem-Fairfield Shipyard, just across the Middle Branch of the Patapsco River from Locust Point and Fort McHenry. (Courtesy of the Library of Congress, Prints and Photographs Division, FSA-OWI Collection.)

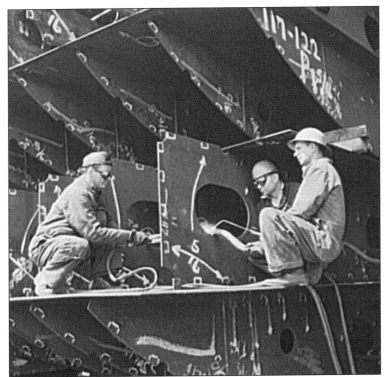

These men weld bulkheads into position. (Courtesy of the Library of Congress, Prints and Photographs Division, FSA-OWI Collection.)

Constantly searching for additional labor to support peak production during World War II, the Fairfield Yards hired women and African Americans in unprecedented numbers. (Courtesy of the Library of Congress, Prints and Photographs Division, FSA-OWI Collection.)

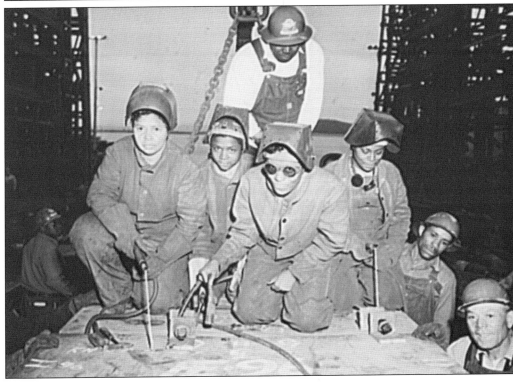

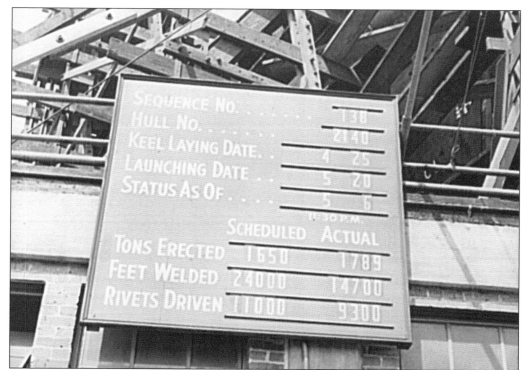

	SCHEDULED	ACTUAL
SEQUENCE NO.		138
HULL No.		2140
KEEL LAYING DATE		4 25
LAUNCHING DATE		5 20
STATUS AS OF		5 6
		11:30 P.M.
TONS ERECTED	1650	1789
FEET WELDED	24000	14700
RIVETS DRIVEN	11000	9300

Production quotas at Fairfield were tracked carefully to maintain the frenzied schedule. (Courtesy of the Library of Congress, Prints and Photographs Division, FSA-OWI Collection.)

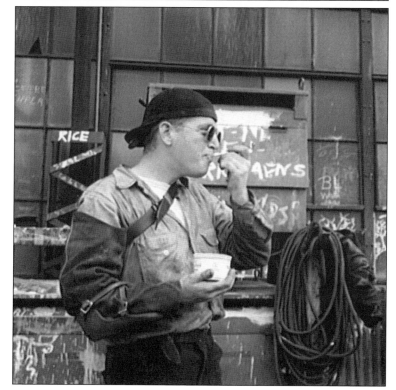

A welder enjoys his break with a little ice cream. (Courtesy of the Library of Congress, Prints and Photographs Division, FSA-OWI Collection.)

These steel beams are tagged and ready for installation. (Courtesy of the Library of Congress, Prints and Photographs Division, FSA-OWI Collection.)

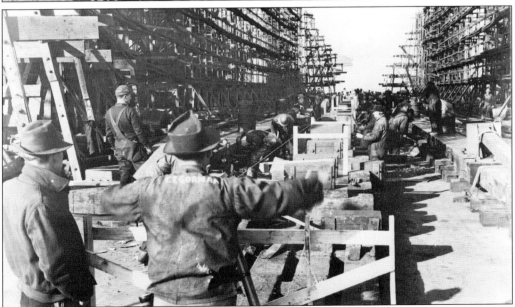

Teamwork and planning were required to rapidly construct the 384 Liberty ships launched from the Fairfield Shipyard. At its peak, shifts worked around the clock, and the shipyard employed 47,000 men and women. The first step to construct a Liberty ship was to align and set the keel blocks with a transit, shown here. After the keel blocks were set, the keel plates were laid to form the ship's structure. (Courtesy of the Library of Congress, Prints and Photographs Division, FSA-OWI Collection.)

In this picture of the ship's forepeak, the 16-ton chain locker and collision bulkhead assembly are being lowered into position using a crane. The ubiquitous shipyard cranes ran parallel to the ships on both sides of the hull. (Courtesy of the Library of Congress, Prints and Photographs Division, FSA-OWI Collection.)

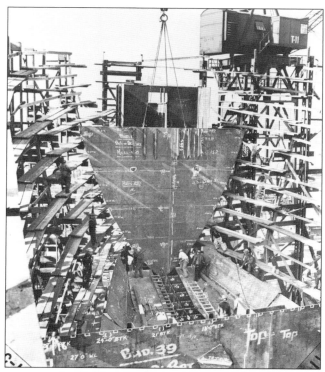

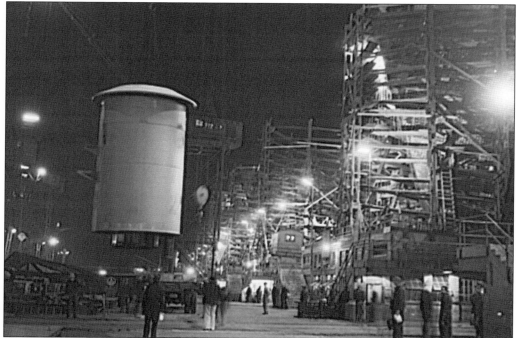

Three shifts were necessary to keep up with the constant demand for transport ships to support the war effort. (Courtesy of the Library of Congress, Prints and Photographs Division, FSA-OWI Collection.)

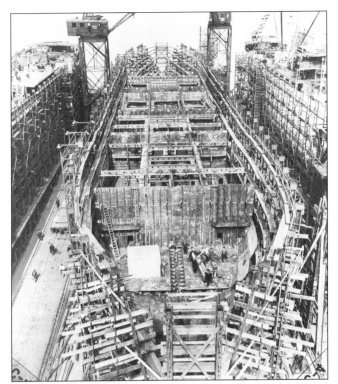

After only six days, over 850 tons of steel has been set, and bulkheads and girders below the second deck are in place. The emphasis will soon shift to fitting the ship out with all of the conduits, piping, and gear necessary to make the it operational. (Courtesy of the Library of Congress, Prints and Photographs Division, FSA-OWI Collection.)

After just 24 days, the ship is completed and ready for christening. Ironically it was only one year after the end of the war that the shipyard was closed and reestablished as the Patapsco Scrap Corporation, which converted the recently completed Liberty ships into scrap for salvage. (Courtesy of the Library of Congress, Prints and Photographs Division, FSA-OWI Collection.)

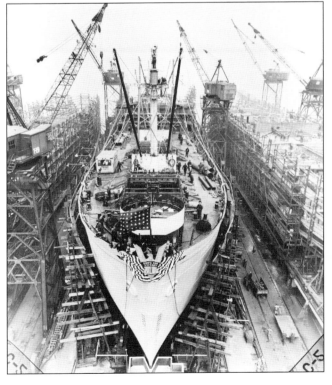

A shortage of traditional laborers during the war compelled a number of local contractors to look beyond their usual hiring pool. (Courtesy of the Library of Congress, Prints and Photographs Division, FSA-OWI Collection.)

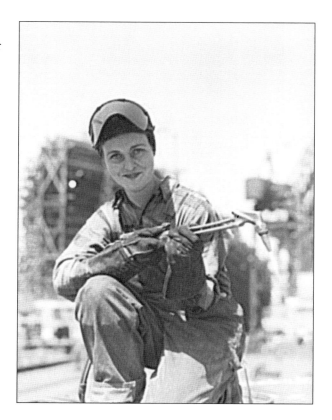

Today Fairfield sits across the water from Locust Point with several of the larger administrative buildings remaining in service. (Courtesy of the author.)

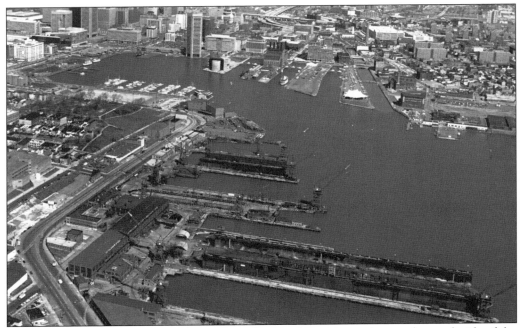

Bethlehem Steel's Key Highway Shipyard was for decades an institution on the south side of the Inner Harbor, finally closing in 1983. This massive industrial facility explains to a great degree why Key Highway is as large as it is today. In this photograph from the 1980s, one can see how the old Baltimore, exemplified by the Key Highway Shipyards, is contrasted with the new Baltimore, symbolized by the National Aquarium and Pier 6 Concert Pavilion on the opposite side of the harbor. (Courtesy of the Baltimore City Department of Planning.)

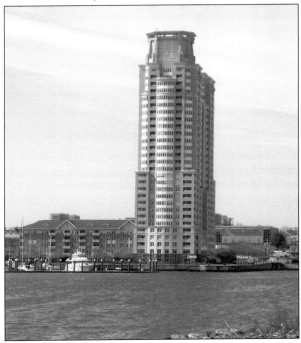

The Bethlehem Steel Key Highway Shipyard site has been redeveloped as a residential community. In an inspired bit of design, the 26-story residential tower was constructed over the shipyard's permanent dry-dock, with parking for tenants' cars filling the void below the waterline formerly filled with ships to be repaired. (Courtesy of the author.)

Five

MANUFACTURING

Baltimore has always had a diverse manufacturing sector, supported by effective transportation by water from the ports and overland by rail. The manufacturing sector has also been one of the hardest hit in the transition from an industrial to a knowledge-based economy. Countless thousands of workers have been laid off as factories throughout the area closed up shop or moved production to locales with lower wages.

Factories, with their multitude of relatively high-wage, low-skill, blue-collar jobs, formed the basis for the growth of Baltimore's middle class throughout much of the 20th century. A factory worker from the first three quarters of the 20th century could expect to earn a decent living with enough left over to pay for an occasional vacation or other luxury. With the loss of the manufacturing sector, many of these good jobs no longer exist for blue-collar workers in Baltimore.

The pride that manufacturers took in their facilities is readily apparent in the magnificent edifices that have been left behind. Many of these sturdy complexes survive to this day, frequently reworked to serve a new role as office space, retail space, or housing.

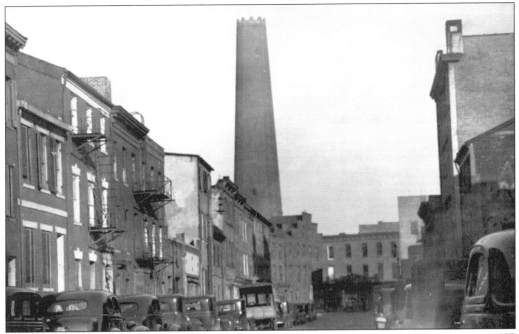

The Phoenix Shot Tower is yet another beloved Baltimore icon. This photograph from January 1937 places the shot tower in context with the other structures along Albermarle Street. (Courtesy of the Enoch Pratt Free Library, Central Library/State Library Resource Center, Baltimore, Maryland.)

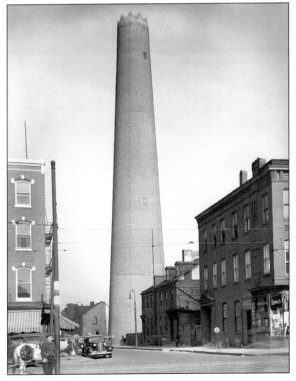

Molten lead was melted in furnaces at the top of the tower and then poured through a sieve, with the droplets cooling as they passed through the air on the way down to a tank of water at the base of the tower. (Courtesy of the Library of Congress, Prints and Photographs Division, HABS/HAER.)

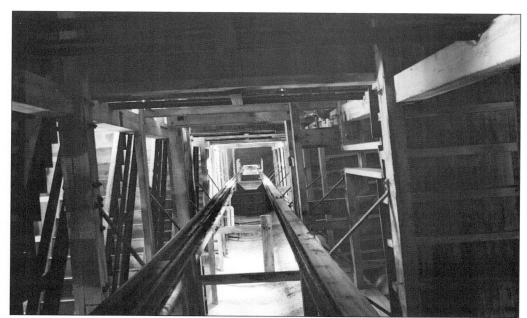

This interior view of the tower highlights the first 12 floors of wood framing and stairs. The upper two floors, where the melting furnaces were located, were composed of half-inch-thick iron. The tower's walls are 4.5 feet thick at the 40-foot-diameter base, decreasing in thickness to 20 inches at the 20-foot-diameter top of the tower. (Courtesy of the Library of Congress, Prints and Photographs Division, HABS/HAER.)

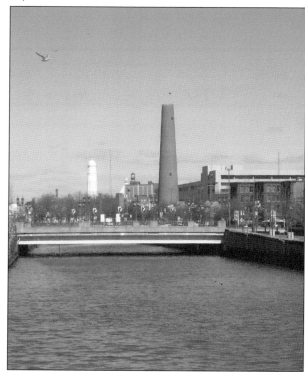

Although lead shot has not been manufactured here since 1892, the tower remains a symbol of Baltimore's early entry into the Industrial Revolution. (Courtesy of the author.)

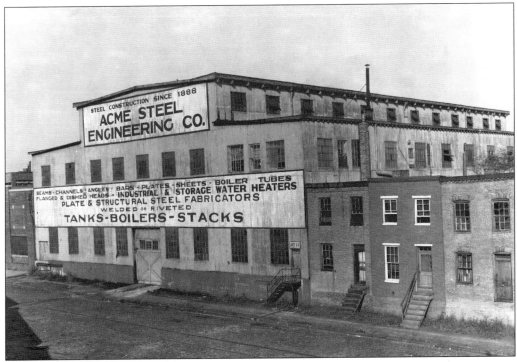

The Acme Steel Engineering Company was typical of numerous fabricators located throughout Baltimore that could produce a wide variety of fabricated iron and steel elements for the construction and manufacturing industries. (Courtesy of the Enoch Pratt Free Library, Central Library/State Library Resource Center, Baltimore, Maryland.)

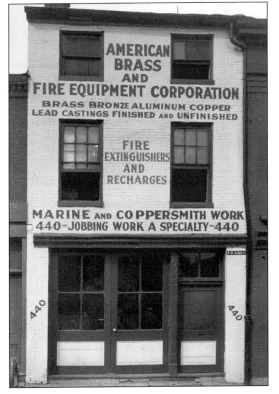

The American Brass and Fire Equipment Corporation was formed when the Diez and Roemer Brass Company merged with the American Fire Extinguisher Company. This photograph from 1930 is of the exterior of their 440 North Front Street address. (Courtesy of the Enoch Pratt Free Library, Central Library/State Library Resource Center, Baltimore, Maryland.)

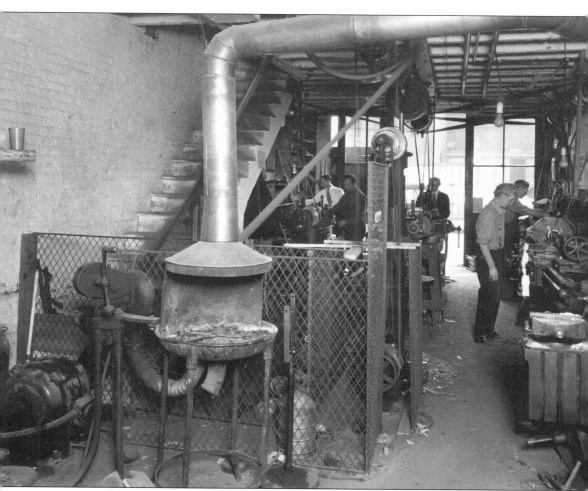

In this interior photograph of the American Brass and Fire Equipment Corporation, the power takeoffs are clearly visible, with their belts powering tools throughout the facility. A small furnace is also visible in the foreground. (Courtesy of the Enoch Pratt Free Library, Central Library/State Library Resource Center, Baltimore, Maryland.)

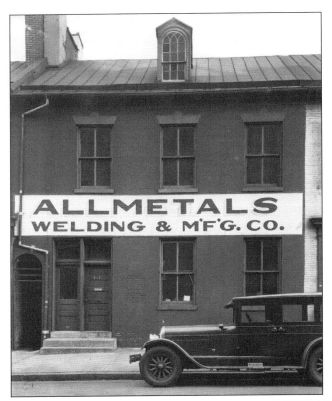

Allmetals Welding and Manufacturing Company was a much smaller concern, located in a converted row house at 413 South Hanover Street in South Baltimore. (Courtesy of the Enoch Pratt Free Library, Central Library/State Library Resource Center, Baltimore, Maryland.)

Another metal-working shop with a long Baltimore history is the Joseph Kavanagh Company. Established in 1866, the company originally produced work as coppersmiths. Later on, the company developed a specialty in bending and rolling miscellaneous steel elements. (Courtesy of the author.)

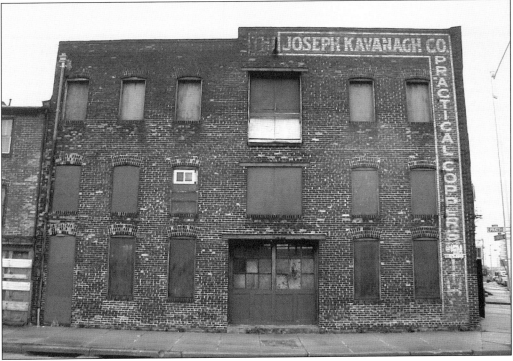

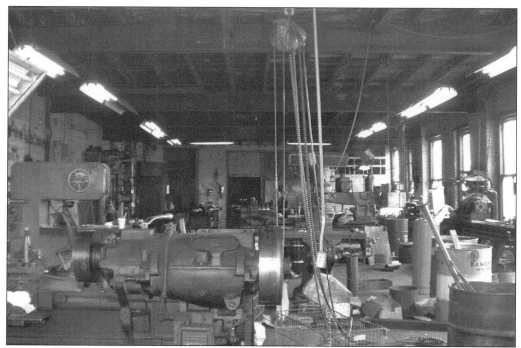

The variety of tools and equipment required to roll a variety of steel shapes for industry and construction is evident in this part of the Kavanagh facility. (Courtesy of the author.)

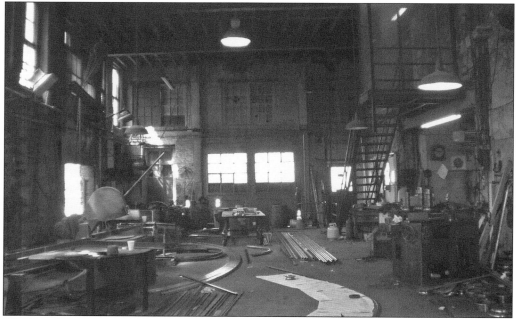

The Joseph Kavanagh Company, still owned by members of the Kavanagh family, relocated in 2004 to be nearer to their customers, most of whom are no longer located in Fells Point, where the Kavanagh facility was located. The site at the corner of Pratt Street and South Central Avenue is currently awaiting redevelopment. (Courtesy of the author.)

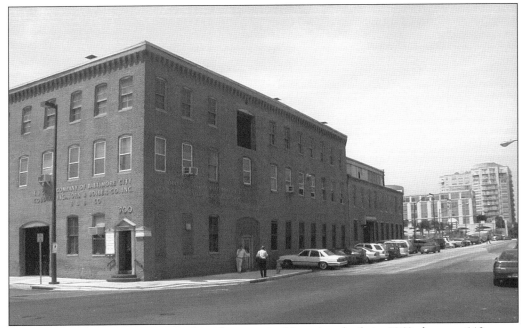

E. J. Codd and Company operated in their original location, built in 1860, for over 140 years. The firm built its reputation over the years for manufacturing and repairing marine machinery and industrial equipment. (Courtesy of the author.)

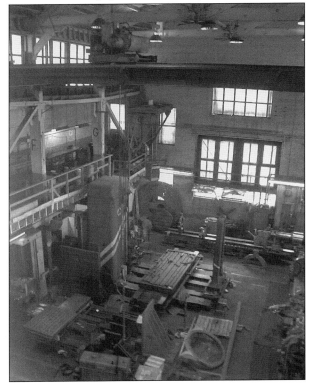

The E. J. Codd facility expanded several times, including growing into the adjacent foundry building. At the time of this facility's closing in 2003, the firm specialized in sugar-refining and chemical industry equipment and repair. (Courtesy of the author.)

This high-bay space in the Codd Building featured a variety of tools and included an overhead crane to maneuver large pieces of equipment being fabricated or undergoing repairs. (Courtesy of the author.)

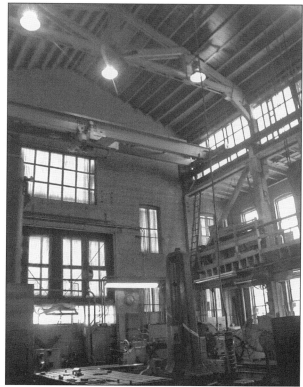

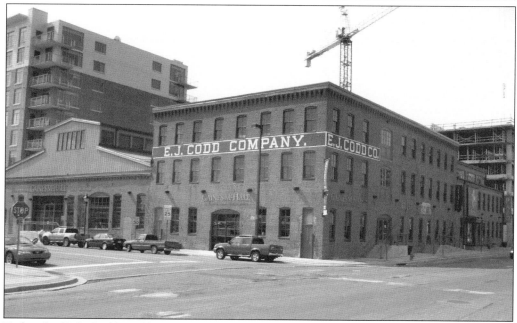

Today the E. J. Codd Building has been converted to a new restaurant and exclusive antiques store, bringing to a close one of the longest continuously operated manufacturing concerns in Baltimore. (Courtesy of the author.)

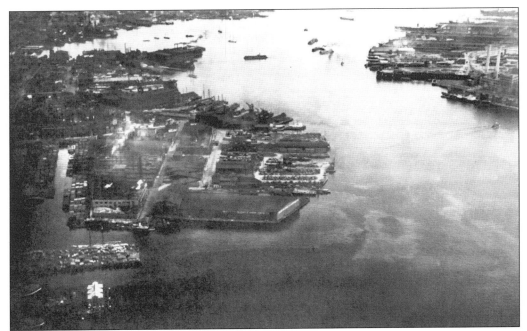

The Allied Chemical Chromium Plant was originally constructed in 1845. Chromate ore was discovered locally as early as 1810, and the ore was processed for use in tanning leather and as a paint pigment. This image from the 1920s indicates how centrally located the 20-acre parcel was at the western end of Fells Point. (Courtesy of the Baltimore City CHAP.)

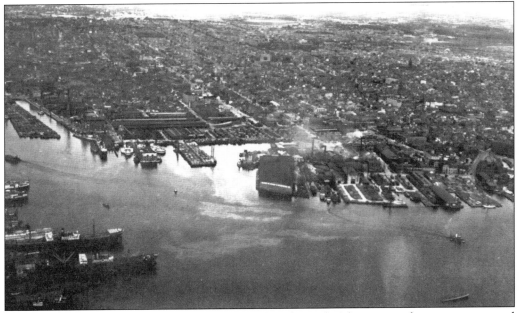

As the local ore deposits rapidly became depleted in the mid-19th century, the company turned to overseas ore deposits to provide the raw materials necessary for the production of various chromium compounds, making the harborside location a natural choice for easy freighter access. (Courtesy of the Baltimore City CHAP.)

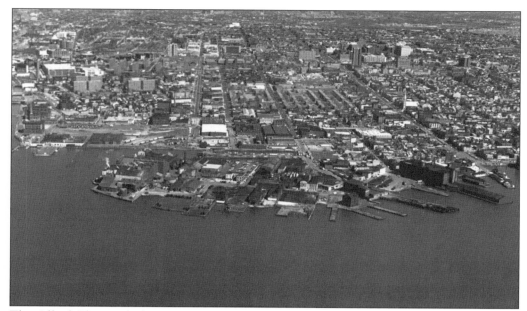

The Allied Chemical plant was active through June 1985, at which time it was closed and 314 workers were discharged. The site then cleared by 1993 and underwent a decade-long cleanup overseen by the U.S. Environmental Protection Agency. (Courtesy of the Baltimore City Department of Planning.)

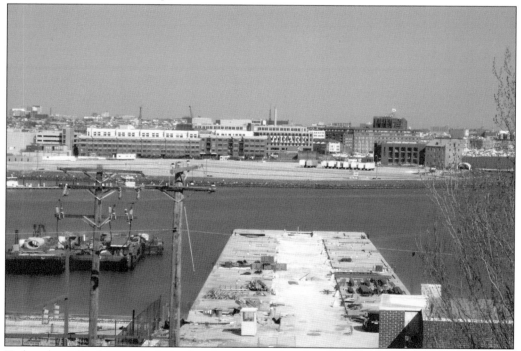

Today the Allied Chemical site has been capped and is awaiting an ambitious mixed-use redevelopment. This parcel is currently the largest remaining undeveloped site along the Inner Harbor. (Courtesy of the author.)

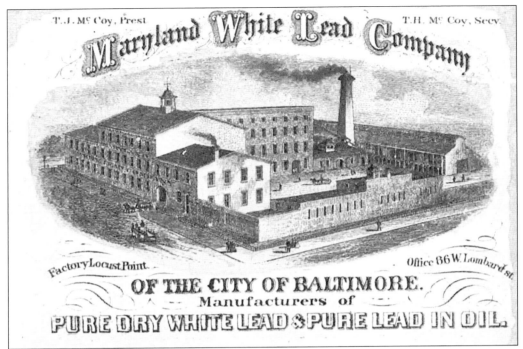

The Maryland White Lead Company's factory was constructed in Locust Point in 1867, making it one of the earliest industrial facilities in this part of Baltimore. The facility produced both dry white lead and white lead in oil, which were used by local paint manufacturers and also shipped throughout the South and Midwest. (Courtesy of the Library of Congress, Geography and Map Division.)

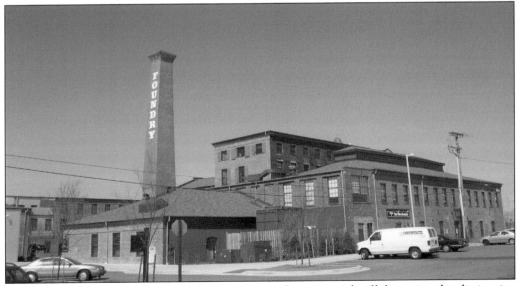

After housing a variety of industrial tenants over the years and still featuring the distinctive tapered, corbelled chimney, the Maryland White Lead facility was redeveloped as the Foundry on Fort in 2002, containing a variety of retail and office tenants. (Courtesy of the author.)

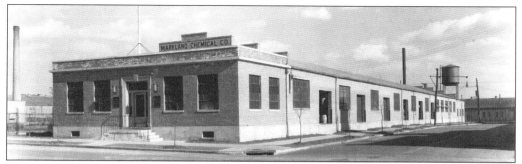

The Maryland Chemical Company distributed industrial chemicals to factories throughout Baltimore. This image from the 1920s highlights the recently constructed office and distribution facility. The office fronted onto Russell Street and was separated from the warehouse behind by a firewall, visible as a stepped gable between the two components. (Courtesy of the Enoch Pratt Free Library, Central Library/State Library Resource Center, Baltimore, Maryland.)

The Maryland Chemical Company expanded their holdings by extending their warehouse facilities to the north and constructing a second floor of offices. While extant today, the buildings are slated for demolition as part of the Gateway South redevelopment. (Courtesy of the author.)

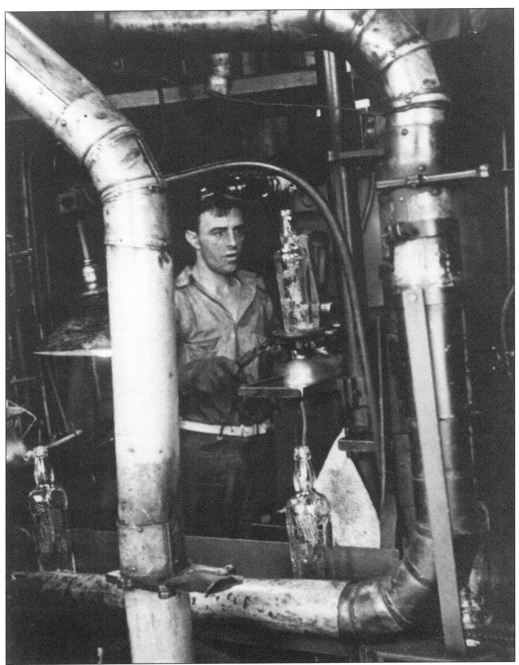

Glass making was a vital support industry in Baltimore, providing storage vessels for a wide variety of beer, soda, cosmetics, and pharmaceuticals manufactured in Baltimore. In this photograph, a worker is hand finishing a bottle. (Courtesy of the Enoch Pratt Free Library, Central Library/State Library Resource Center, Baltimore, Maryland.)

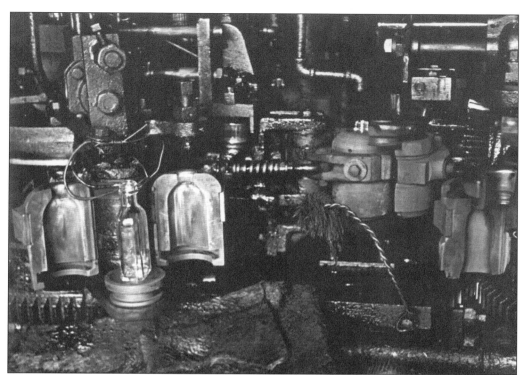

Even when automated, the manufacturing of glass bottles was hot, dirty work, and the molding machines still required constant care and attention from workers. (Courtesy of the Enoch Pratt Free Library, Central Library/State Library Resource Center, Baltimore, Maryland.)

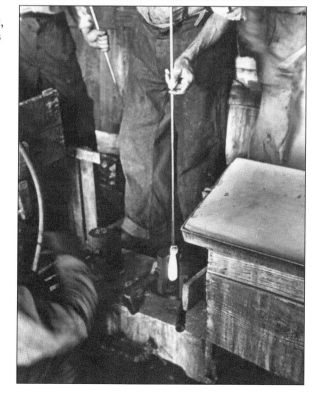

Prior to automation, workers would use a blowpipe to force molten glass into an iron mold. (Courtesy of the Enoch Pratt Free Library, Central Library/State Library Resource Center, Baltimore, Maryland.)

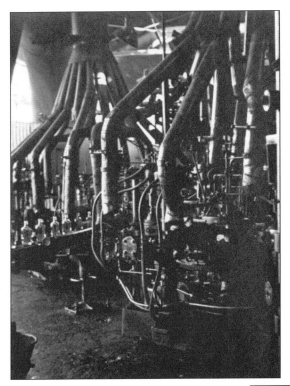

Multi-pot furnaces enabled the automated bottle-blowing machines to speed up production. As glass companies such as the Carr-Lowery Glass Company and Maryland Glass Company expanded, they incorporated the latest innovations to produce larger and larger furnaces. (Courtesy of the Enoch Pratt Free Library, Central Library/State Library Resource Center, Baltimore, Maryland.)

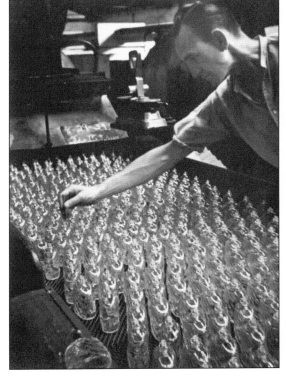

Quality control and inspections were vital to ensure consistent and blemish-free containers produced by the automated production lines. (Courtesy of the Enoch Pratt Free Library, Central Library/State Library Resource Center, Baltimore, Maryland.)

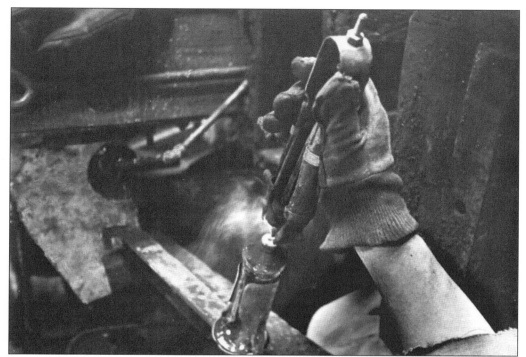

Handwork with molten glass required a deft touch, coupled with skill and training. Craftspeople were required not only to manipulate the glass, but also to run the larger automated machines and cut the dies used in forming the bottles. (Courtesy of the Enoch Pratt Free Library, Central Library/State Library Resource Center, Baltimore, Maryland.)

Today there is little left of Baltimore's once-thriving glass industry. The Carr-Lowery Glass Company site has been completely cleared of all buildings as the initial phase of an ambitious redevelopment plan for Westport gets underway, while all that remains of Captain Emerson's Maryland Glass Company is the deteriorating and graffiti-scarred site pictured here. (Courtesy of the author.)

The Crown Cork and Seal Company grew rapidly in the late 19th century after the invention of the single-use, corked-lined bottle cap. The original plant, constructed in 1898, still stands in the 1500 block of Guilford Avenue, although the company relocated to larger facilities in Highlandtown in 1928. The eclectic Victorian facade of this building is another excellent example of Baltimore's "high style" industrial buildings. (Courtesy of the Library of Congress, Prints and Photographs Division, HABS/HAER.)

The original Crown Cork and Seal Building is now used by a number of artists for studio space and is a key anchor of Baltimore's Station North Arts District. Not in this picture is the small power substation tucked in among the much larger structures. (Courtesy of the author.)

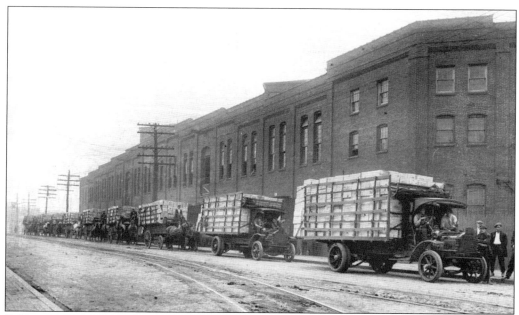

Baltimore was a center for the canning industry in the early 20th century. Originating from a need to can oysters from the Chesapeake Bay and fresh produce from Anne Arundel County and the Eastern Shore, Baltimore was home to both canneries and can manufacturing sites. One of the most prominent can manufacturing plants was the American Can Company in Canton. Here trucks are lined up along Boston Street in the 1920s. (Courtesy of the Library of Congress.)

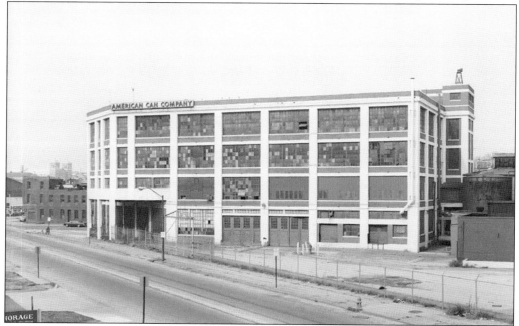

This photograph of the American Can Company was taken after the plant closed in the early 1980s, prior to redevelopment. (Courtesy of the Library of Congress, Prints and Photographs Division, HABS/HAER.)

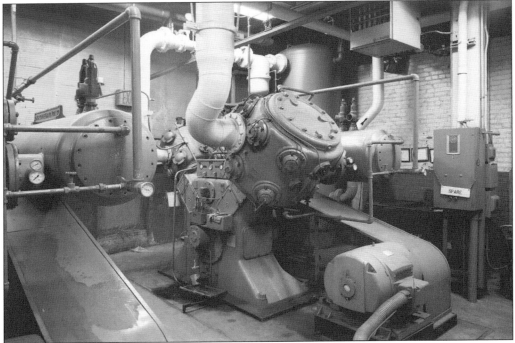

These generators in the boiler house produced power for the American Can Company. The generators were retained as sculpture when the complex was redeveloped in the late 1990s. (Courtesy of the Library of Congress, Prints and Photographs Division, HABS/HAER.)

The generators pictured have been reworked as sculpture at the renovated American Can Company. The building housing the generators was razed during redevelopment, while the original boiler house behind the generators is now a restaurant. (Courtesy of the author.)

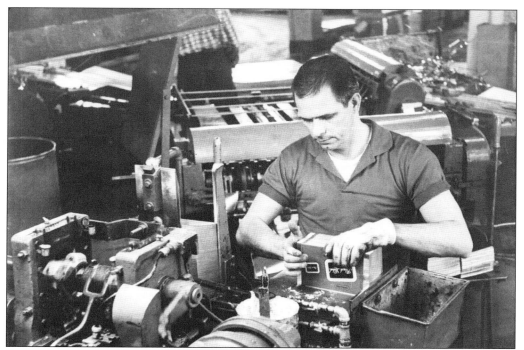

Pictured is a worker on the American Can Company assembly line. (Courtesy of the Library of Congress, Prints and Photographs Division.)

The American Can Company site was the first project to complete Maryland's Brownfields Voluntary Cleanup Program, and it has been successfully redeveloped into retail and office space. The can company is widely credited with helping spark the rebirth of Baltimore's Canton neighborhood. (Courtesy of the author.)

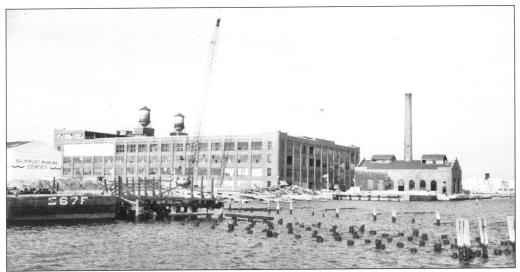

The Tin Decorating Company was once one of the largest metal lithography plants in the world and once contained over 3,300 individual machines capable of producing five million decorative metal tins per day. This waterside complex ceased operations in 1965 and was converted to condominiums and apartments in the 1980s. In this pre-development photograph, the factory building is on the left with the power plant, now a restaurant, visible on the right. (Courtesy of Struever Brothers, Eccles, and Rouse, Inc.)

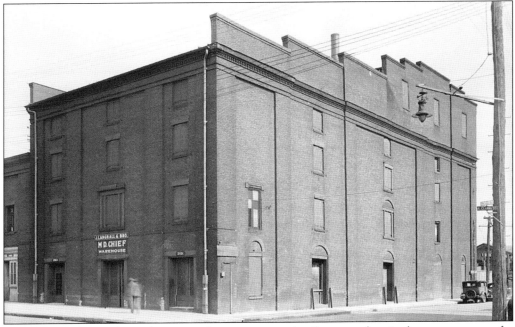

Thanks to Baltimore's combination of port access and rail access, the city became a center for the sugar trade, boasting of 10 sugar refineries by 1900. These refineries, such as the one in Fells Point illustrated here, were purchased and closed by the Sugar Trust to control competition. The Sugar Trust was dissolved in 1911 in the wake of the famous Standard Oil federal "trust busting" case. (Courtesy of the Library of Congress, Prints and Photographs Division, HABS/HAER.)

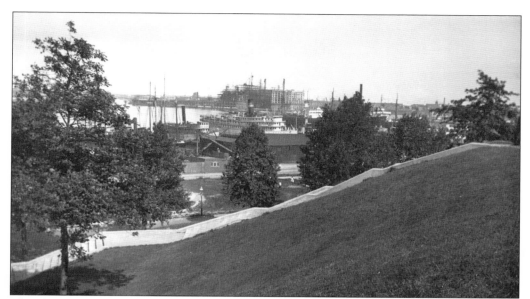

This shot, taken from Federal Hill in June 1921, shows the Domino Plant (then known as the American Sugar Refinery) under construction. (Courtesy of the Enoch Pratt Free Library, Central Library/State Library Resource Center, Baltimore, Maryland.)

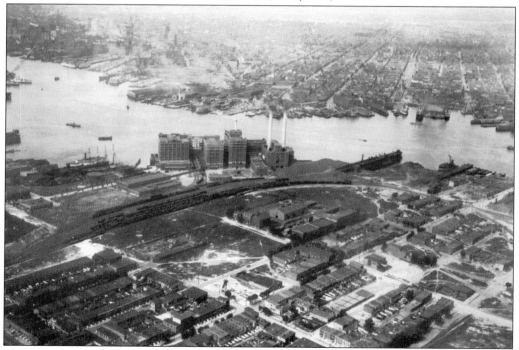

This aerial view from the mid-1920s of the Domino Sugar Refinery shows the relationship between the plant and Locust Point, with the harbor to the north providing water access for the ships bearing raw sugar from points south and B&O rail lines to the south hauling in coal to power the refinery complex and transporting the processed sugar to market. (Courtesy of the Baltimore City CHAP.)

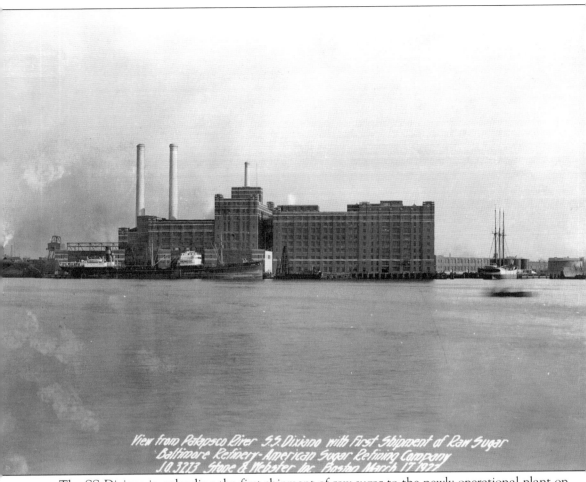

View from Patapsco River S.S. Dixiano with First Shipment of Raw Sugar Baltimore Refinery-American Sugar Refining Company J.O. 3273 Stone & Webster Inc. Boston March 17 1922

The SS *Dixiano* is unloading the first shipment of raw sugar to the newly operational plant on March 17, 1922. Half of the enormous main plant building is actually built on a pier over the harbor. (Courtesy of the Enoch Pratt Free Library, Central Library/State Library Resource Center, Baltimore, Maryland.)

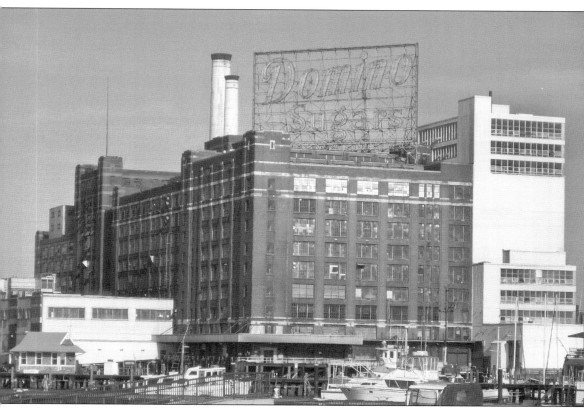

Today the Domino Sugar Plant is one of the few receivers of bulk cargo left in the Port of Baltimore. To this day, large cranes scoop buckets of raw sugar out of the holds of cargo ships and dump it onto a conveyor for transport and processing. The large red neon sign mounted on top of the building requires two full-time electricians to maintain this elaborate nighttime harborside icon. (Courtesy of the author.)

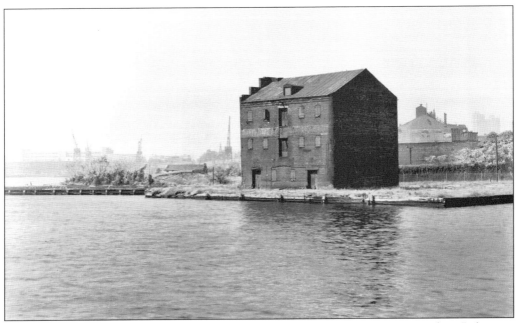

The Levering Coffee Warehouse dated to the latter part of the 19th century, when Baltimore became a major coffee port with easy access to the coffee plantations of South America. The warehouse sported several unusual features, including rounded brick masonry corners and an unusual roof line consisting of a gabled end on the east side and a stepped parapet on the west side. (Courtesy of the Library of Congress, Prints and Photographs Division, HABS/HAER.)

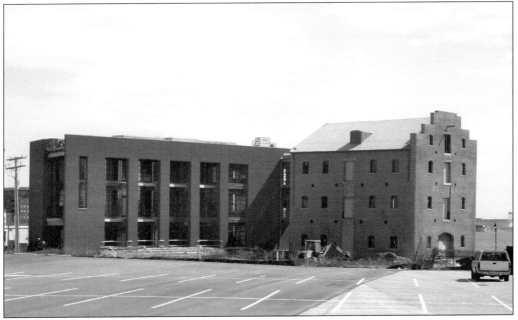

The coffee warehouse was damaged by fire in the 1990s, has undergone a substantial reconstruction, and will soon reopen as the Frederick Douglass–Isaac Myers Maritime Park. (Courtesy of the author.)

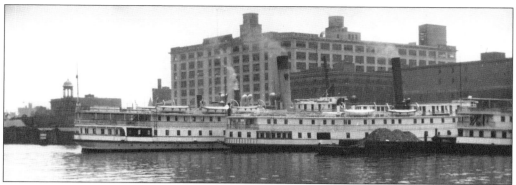

The nine-story McCormick and Company building was constructed on Light Street in 1921 and included production facilities for refining and packaging a variety of spices, as well as their corporate offices, test kitchens, research labs, and, on the seventh floor, a recreation of an English tea house designed by local architect Edwin Tunis. (Courtesy of the Enoch Pratt Free Library, Central Library/State Library Resource Center, Baltimore, Maryland.)

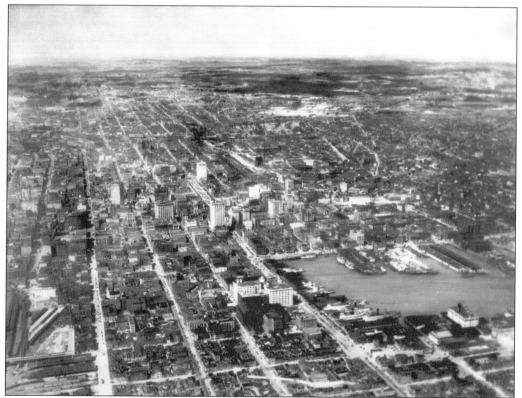

The white L-shaped McCormick and Company building is clearly visible in the middle foreground of this aerial photograph of the harbor from 1927. McCormick and Company has grown to be the world's largest manufacturer of spices and specialty foods. The company eventually created a new corporate headquarters in Hunt Valley, and when the building was demolished in 1990, the aroma of cinnamon and other spices wafted across downtown. (Courtesy of the Enoch Pratt Free Library, Central Library/State Library Resource Center, Baltimore, Maryland.)

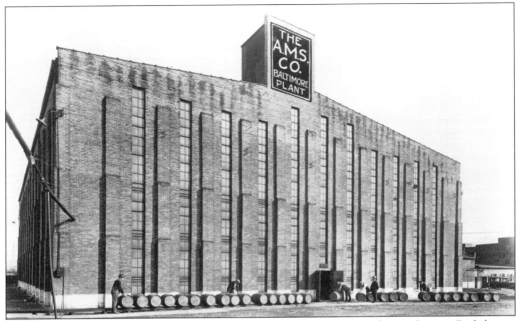

The American Medicinal Spirits Company set up their Baltimore plant during the post-Prohibition frenzy to bring alcohol-distilling capacity back to the United States. (Courtesy of the Enoch Pratt Free Library, Central Library/State Library Resource Center, Baltimore, Maryland.)

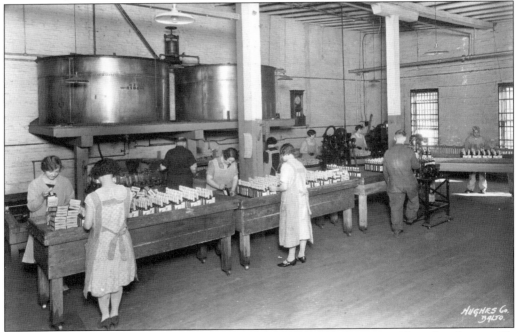

Here is the packaging line for the American Medicinal Spirits Company. Note the classic mill-building construction evident in the heavy timber framing and brick masonry exterior walls. (Courtesy of the Enoch Pratt Free Library, Central Library/State Library Resource Center, Baltimore, Maryland.)

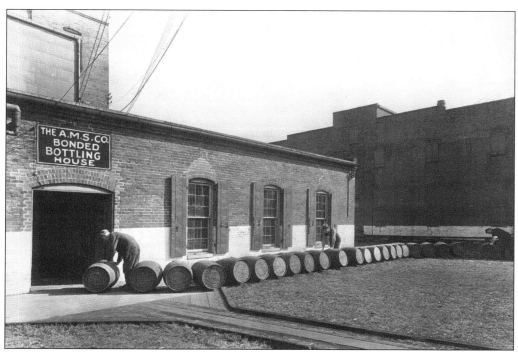

Here workers are rolling barrels of aged Spring Garden Whiskey into the American Medicinal Spirits Company bottling house in preparation for bottling the whiskey. (Courtesy of the Enoch Pratt Free Library, Central Library/State Library Resource Center, Baltimore, Maryland.)

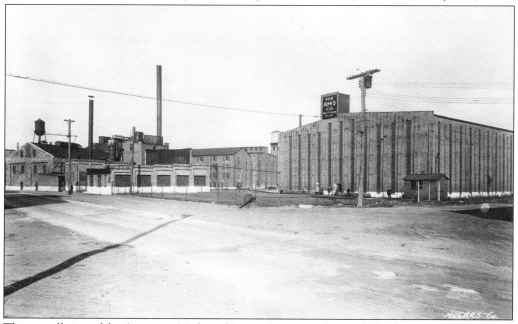

This overall view of the American Medicinal Spirits Company plant includes the recently constructed warehouse building on the right and an older stone building to the left. (Courtesy of the Enoch Pratt Free Library, Central Library/State Library Resource Center, Baltimore, Maryland.)

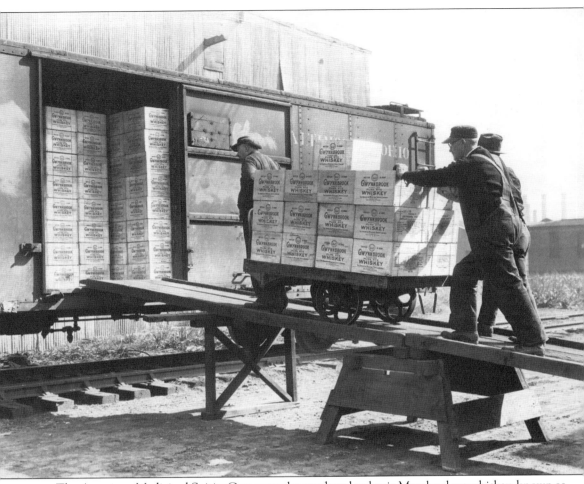

The American Medicinal Spirits Company also produced a classic Maryland rye whiskey, known as Gwynnbrook Rye Whiskey, shown here loaded on to a B&O Rail freight car. (Courtesy of the Enoch Pratt Free Library, Central Library/State Library Resource Center, Baltimore, Maryland.)

The Weissner (later American) Brewery is one of the most unusual industrial buildings in Baltimore. Designed in the Victorian Gothic style, the brewery has been a landmark on North Gay Street since its construction in 1887. (Courtesy of the Library of Congress, Prints and Photographs Division, HABS/HAER.)

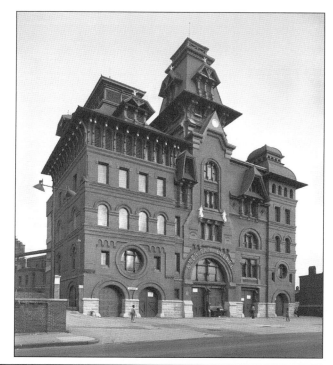

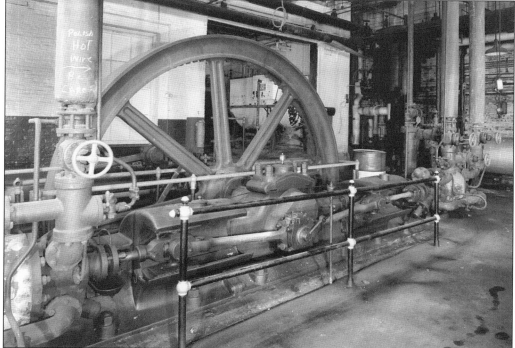

This interior view of the Weissner Brewery features one of the large engines used to power the brewing operations. (Courtesy of the Library of Congress, Prints and Photographs Division, HABS/HAER.)

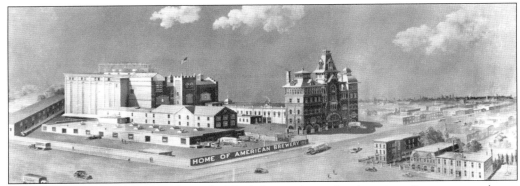

This rendering from just after the end of Prohibition shows the American Brewery complex at its peak. Today only the brewhouse (right-hand side) and the bottling plant (the low building on the left-hand side) remain. (Courtesy of the Enoch Pratt Free Library, Central Library/State Library Resource Center, Baltimore, Maryland.)

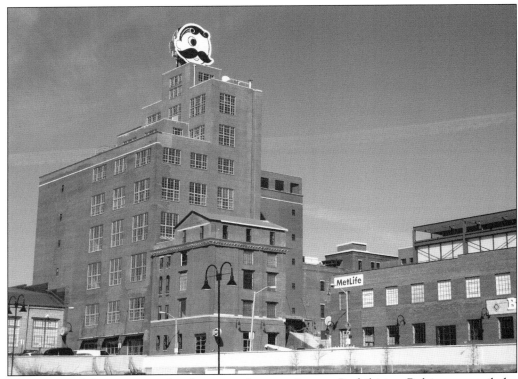

The National Brewery was the dominant brewery in post-Prohibition Baltimore until the consolidation and domination of national brands led to the closure of many regional breweries in the 1960s and 1970s. National Bohemian, the brewery's flagship beer—better known as "Natty Boh" to Baltimoreans—and the firm's mascot, the one-eyed Boh Man, are still beloved icons in the city. The brewery, whose marketers dubbed Maryland "The Land of Pleasant Living," has been redeveloped into commercial office space with great views of the harbor from some of the higher points in the building. (Courtesy of the author.)

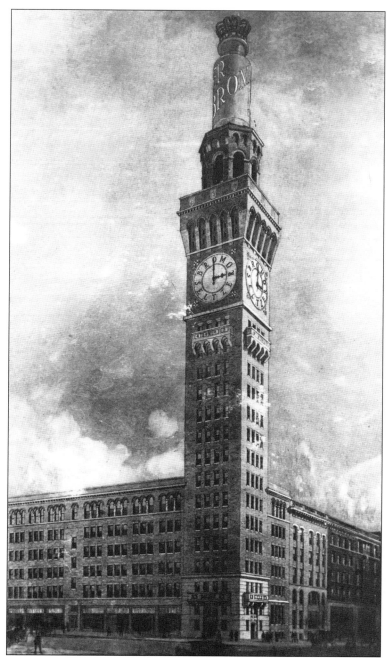

One of Baltimore's truly idiosyncratic landmarks is the Bromo Seltzer Tower, built in 1911. This early rendering shows both the iconic tower and the six-story factory building attached to the tower. Originally crowning the tower was a 51-foot-tall, 27-ton revolving bottle of Bromo Seltzer. This bottle was illuminated by 596 lights and was reported to be visible from Maryland's Eastern Shore, some 60 miles away. The bottle had to be removed in 1930 when it was discovered that vibrations from the rotating bottle were creating cracks in the tower. (Courtesy of the Enoch Pratt Free Library, Central Library/State Library Resource Center, Baltimore, Maryland.)

In this west-facing view, the Bromo Seltzer Tower building is clearly visible among the jumble of Baltimore's west side, still crowned by the oversize bottle atop the tower. (Courtesy of the Enoch Pratt Free Library, Central Library/State Library Resource Center, Baltimore, Maryland.)

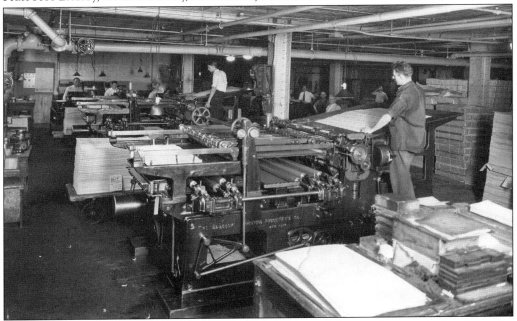

Capt. Isaac E. Emerson invented and manufactured Bromo Seltzer and recognized early on the importance of controlling all aspects of production. Not only did the Emerson Drug Company manufacture products such as Bromo Seltzer, it also produced the labels, and Captain Emerson went so far as to create the Maryland Glass Company in 1910 specifically to produce the bottles for his products. Pictured here is the printing department. (Courtesy of the Enoch Pratt Free Library, Central Library/State Library Resource Center, Baltimore, Maryland.)

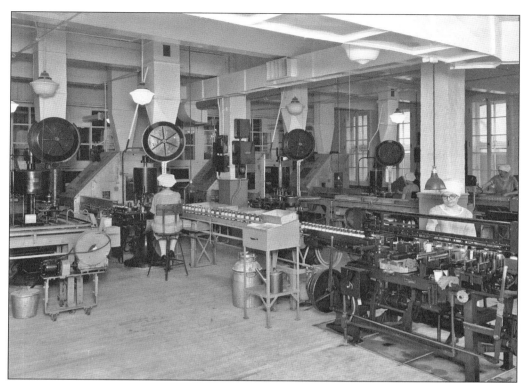

This view of the filling room shows several women working on the production line in the factory building. (Courtesy of the Enoch Pratt Free Library, Central Library/ State Library Resource Center, Baltimore, Maryland.)

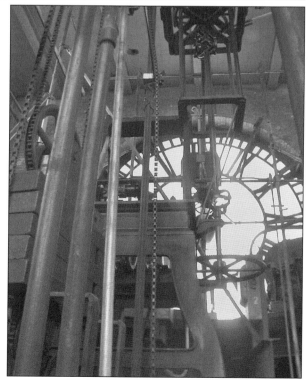

The tower, designed by architect Joseph Sperry, was patterned after Florence's Palazzo Vecchio. At the top of the tower sits the clock room with a complex geared drive controlling all four clock faces simultaneously, shown here. The internally illuminated clock face has "BROMO SELTZER" inscribed on it. (Courtesy of the author.)

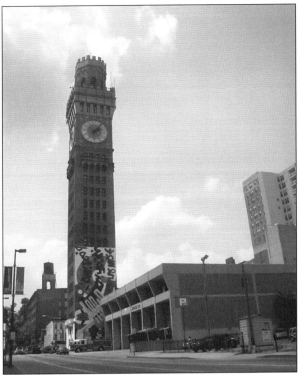

The Bromo Seltzer Tower building was transferred to the City of Baltimore with the understanding that at least the tower must be preserved. The surrounding six-story plant was torn down in 1969, and the city's Central Fire Station now occupies the site. The tower, rechristened the Baltimore Arts Tower, provided office space for arts-related city agencies for several decades and now sits vacant, awaiting redevelopment. (Courtesy of the author.)

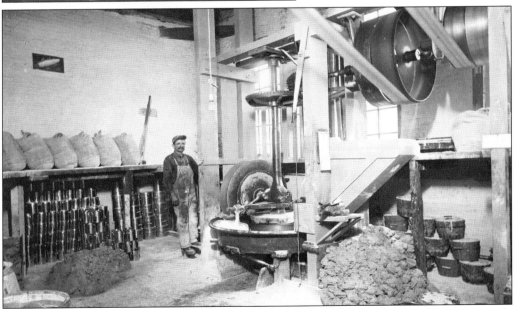

Baltimore became a regional center for the paint industry, thanks in no small part to ready access to raw materials provided by the port and manufacturers such as the Maryland White Lead Works on Fort Avenue and the Allied Chemical Chrome Works in Fells Point. In this c. 1900 photograph, a worker is seen mixing the raw ingredients for the paint. (Courtesy of the Baltimore Museum of Industry.)

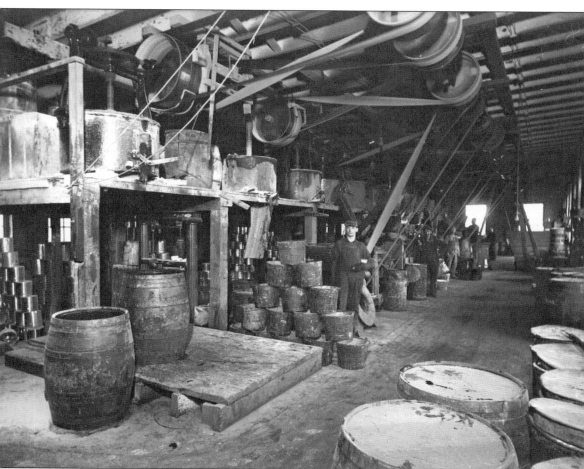

Mixing all of the materials to produce the final canned liquid paint could be a rather untidy process that also required a great deal of power. Note the large number of belt drives visible in this late-19th-century photograph. (Courtesy of the Baltimore Museum of Industry.)

This interesting building was originally built as a purifying house and meter room for the Equitable Gas Light Company. Later this building became the Chesapeake Iron Works and was then integrated into the H. B. Davis Company Paint Factory. (Courtesy of the author.)

Fronting on to Key Highway, the distinctive curving facade of the Baltimore Copper Paint Company has been incorporated into the American Visionary Arts Museum. Copper paint was used to reduce plant growth on ship hulls, and every boat that defended the America's Cup before the introduction of aluminum hulls used products from the Baltimore Copper Paint Company. (Courtesy of the author.)

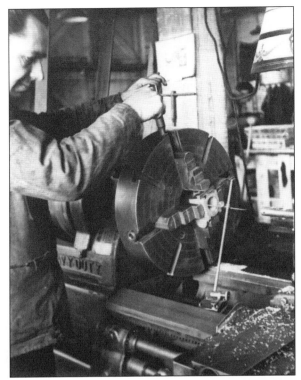

Baltimore had a constant demand for skilled craftsmen who could create complex components with great precision. In this image, a worker uses a metal lathe to produce components for the aircraft industry. (Courtesy of the Enoch Pratt Free Library, Central Library/State Library Resource Center, Baltimore, Maryland.)

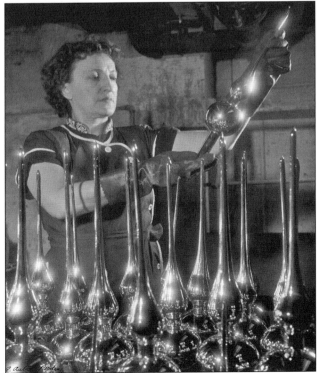

Women were also active in Baltimore's manufacturing workforce. Here a worker is producing decorative ornaments to top off Christmas trees. (Photograph by A. Aubrey Bodine, copyright Jennifer B. Bodine.)

Here a worker is assembling cast and milled parts for use in the aircraft industry. (Courtesy of the Enoch Pratt Free Library, Central Library/ State Library Resource Center, Baltimore, Maryland.)

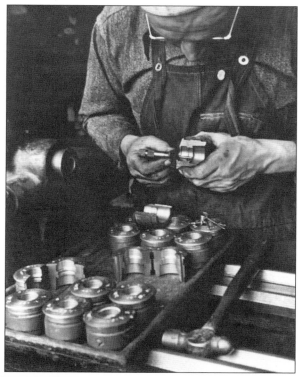

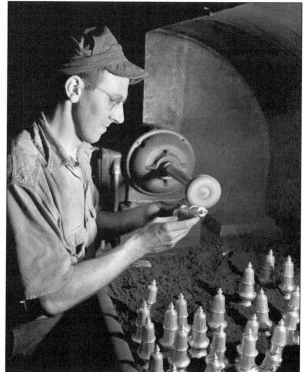

Founded by Charles Stieff in 1892, Stieff Silver was one of the leading silversmiths in the country and became known for their ornate repoussé work. In this image, a worker is buffing salt and pepper shakers at the Stieff Silver facility. (Photograph by A. Aubrey Bodine, copyright Jennifer B. Bodine.)

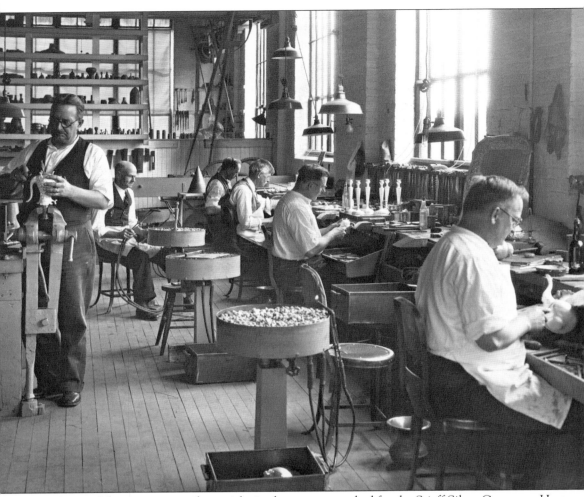

Some of the preeminent silversmiths in the country worked for the Stieff Silver Company. Here the craftsmen are working on a variety of coffee pots and candlesticks in the Wyman Park facility. (Courtesy of the Baltimore Museum of Industry.)

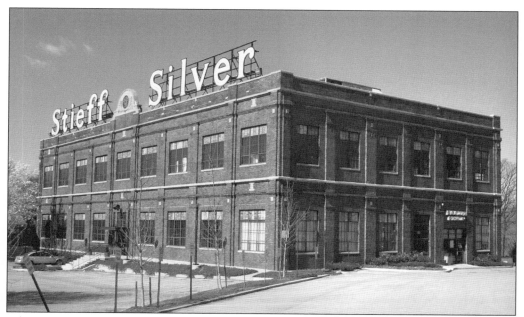

After purchasing S. Kirk and Sons in 1979, the renamed Kirk-Stieff Silver continued to produce a wide variety of silverware—everything from basic table settings to the Preakness Cup. The firm was purchased by Lenox, Inc., in 1990, and in 1999, Lenox consolidated operations with other silverware brands it owns, shuttering the Baltimore facility. The Stieff Silver building has been successfully redeveloped as office space, with the prominent illuminated sign still visible. (Courtesy of the author.)

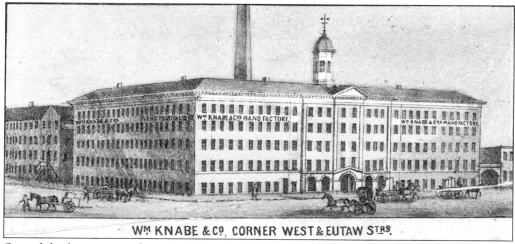

One of the largest manufacturing plants in Baltimore in the second half on the 19th century was William Knabe and Company's piano plant on South Eutaw Street. One of the things that distinguished Knabe from its competitors was the fact that Knabe manufactured all their parts, from casting the frames to producing the specialty wood parts, unlike most other piano manufacturers in Baltimore, who merely assembled pieces produced elsewhere. (Courtesy of the Library of Congress, Geography and Map Division.)

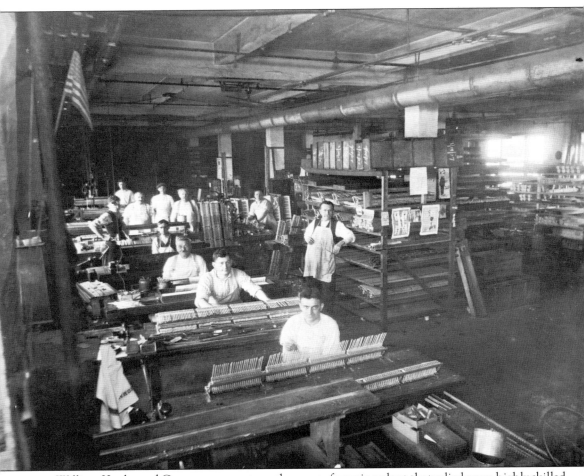

William Knabe and Company was yet another manufacturing plant that relied upon highly skilled labor to fabricate and assemble the complex instruments, as seen in this photograph from 1902. Production was moved from the facility in 1929, and after that, the facility produced a variety of paper products until 1990, when the site was razed for a parking lot at Camden Yards. (Courtesy of the Baltimore Museum of Industry.)

Six

INFRASTRUCTURE

As Baltimore grew in population, there developed a need for more and more infrastructure to support the expanding numbers of residents and businesses. Gas for lighting and heat, fresh water for drinking, electricity and phone service, as well as a functioning sewage system were all necessary as Baltimore's population packed into the city with greater and greater density.

While improvements were being made to sanitation and lighting, they were also being made to public transportation. A variety of cable car and electric traction streetcar lines were introduced into the city to provide transportation to all of the residents who were making Baltimore their home.

Most of these infrastructure facilities are over 100 years old and still intact. These robust and well-designed structures are a testimony to the significance placed on the new technologies that were being incorporated into city life. Rather than constructing a mere functional vessel to house the infrastructure, these facilities celebrated the progress of electricity, sewers, a safe water supply, and other elements of modern life.

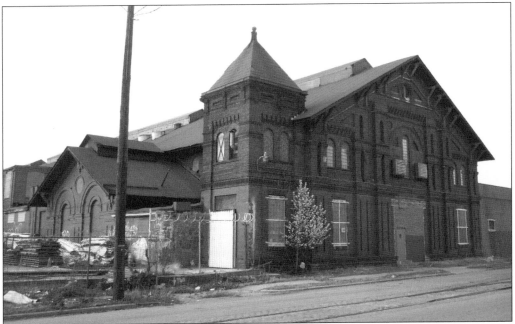

This magnificent structure was originally built as the generator house and retort house for the Chesapeake Gas Company. Later this building was converted to a foundry for the Baltimore Gas Appliance Manufacturing Company. The high-style design and exceptional brickwork are indicative of the importance the owners placed upon this industrial facility. The building now appears to be used for storage. (Courtesy of the author.)

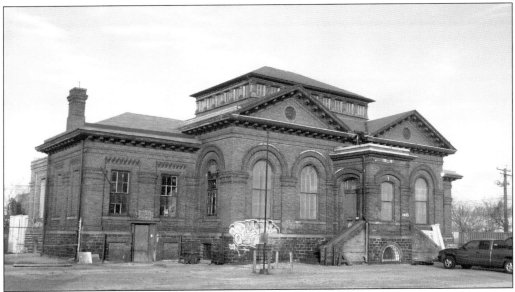

This building was originally constructed as a valve room and offices for the Consolidated Gas Company. The formal, symmetric facade lends weight and significance to this most prosaic building. This grand, formal structure has recently been converted to Housewerks, an architectural salvage company. (Courtesy of the author.)

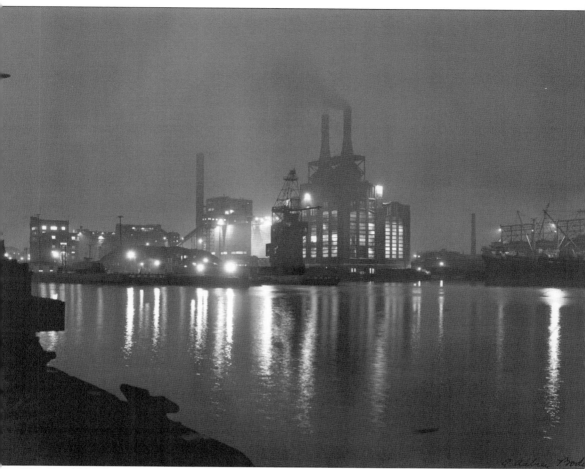

The Gould Street Power Plant was one of the first large-scale generating stations in the city. The capacity of the plant was more than doubled when an additional generating unit was constructed in 1952. (Photograph by A. Aubrey Bodine, copyright Jennifer B. Bodine.)

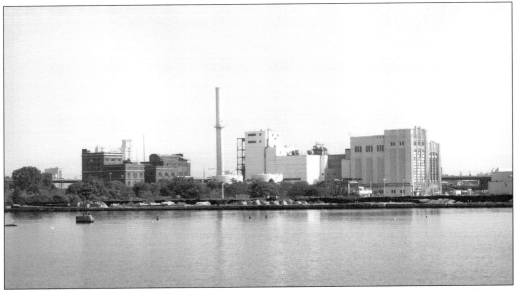

Decommissioned prior to the early 1990s, the Gould Street plant sits at the east end of the Port Covington complex, awaiting a new use. (Courtesy of the author.)

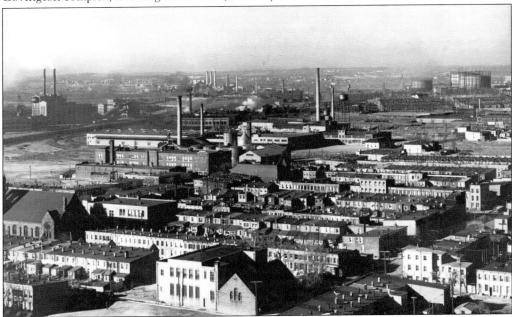

This photograph of South Baltimore highlights the many utilities located in this part of the city. The Gould Street Power Station is visible at the left-hand side of the image, the Westport Power Station is visible across the middle branch of the Patapsco River in the background, and the large gasholders of the Baltimore Gas and Electric Company's Spring Garden Station are visible in the right-hand side of the picture. Prior to receiving supplies from a natural gas pipeline, first coal gas then carbureted water gas was produced on site, stored in the gasholders, and then distributed throughout Baltimore. (Courtesy of the Enoch Pratt Free Library, Central Library/State Library Resource Center, Baltimore, Maryland.)

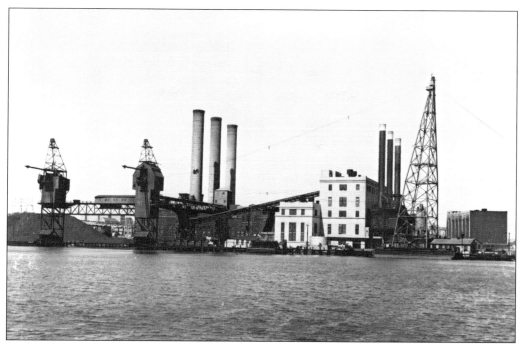

With parts of the Westport Power Station dating back to 1905, this facility was critical to the early growth of Baltimore, as at one point the plant was providing all of the Consolidated Gas, Electric Light and Power Company's electricity. The plant was situated to take advantage of both railroad and barge deliveries of coal to feed the massive boilers. (Courtesy of the Baltimore Museum of Industry.)

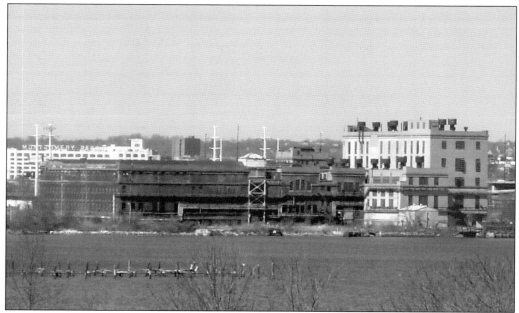

Decommissioned for several years now, the grand architecture of the Westport Power Station will hopefully be retained as the surrounding neighborhood is redeveloped. (Courtesy of the author.)

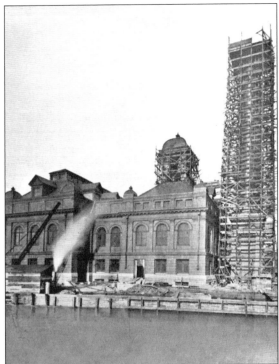

The Eastern Avenue Pumping Station was constructed by the Baltimore Sewerage Commission in 1910 to help reduce pollution in the harbor. With the advent of modern plumbing, more and more waste was discharged into the sewers, which in turn discharged directly into the tributaries that drained into the harbor. (Courtesy of the Baltimore Museum of Industry.)

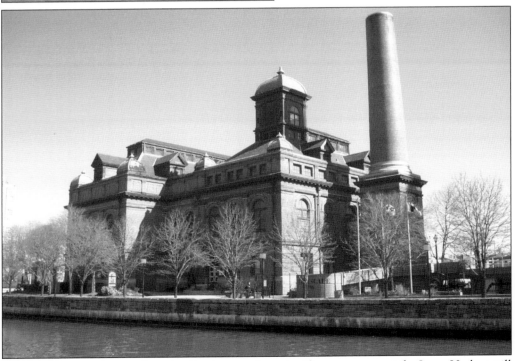

Today the Eastern Avenue Pumping Station remains a significant presence at the Inner Harbor, still pumping sewage and also housing the city's Public Works Museum. (Courtesy of the author.)

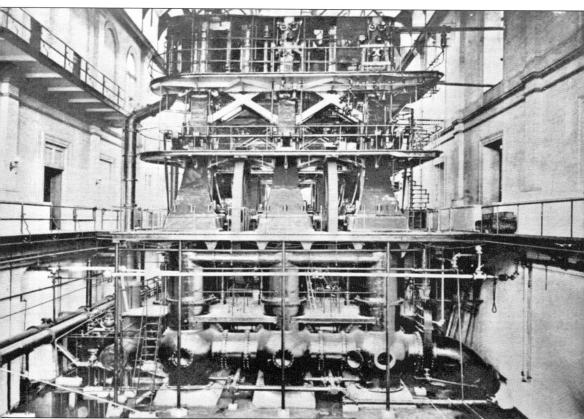

The bulk of the Eastern Avenue Pumping Station was originally built to contain the massive engines seen here, needed to provide the power necessary to pump sewage through the interceptor and up and over the hills of East Baltimore to a newly constructed Sewage Treatment Plant on the Back River. (Courtesy of the Baltimore Museum of Industry.)

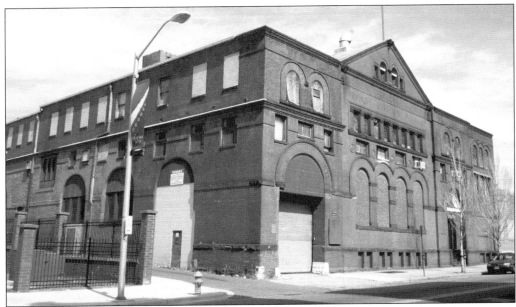

Originally built as a cable powerhouse for the Baltimore City Passenger Railway Company in 1892, this complex was converted to a manufacturing plant by Hendler's Creamery Company after the streetcar line converted from cable to electric traction. After making some of the best ice cream in Baltimore for decades, the plant was converted to a city jobs training center and then eventually closed. The building is now vacant and awaiting redevelopment. (Courtesy of the author.)

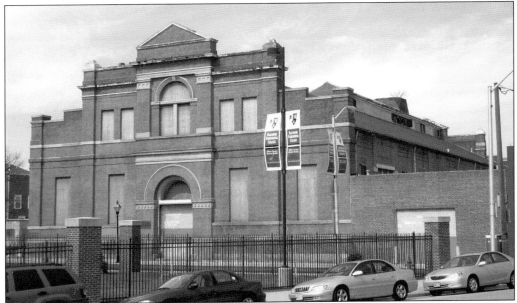

Originally built by the Baltimore Traction Cable Company in 1891, this building housed the two large engines used to power one of Baltimore's short-lived attempts at a cable car line. After housing a variety of tenants, the facility is now owned by the city and is awaiting redevelopment. (Courtesy of the author.)

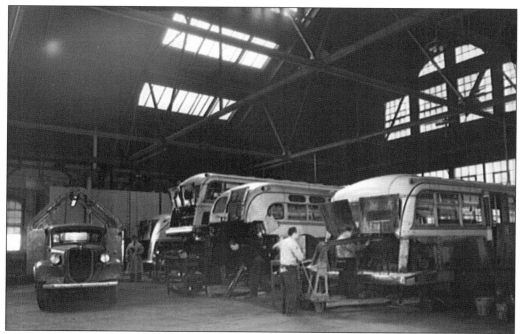

The massive Carroll Park Shops were constructed by the United Railways Company in 1900 to provide construction and repair facilities for the United Railway lines streetcar equipment. Four long bays of structure provided adequate space for all manner of construction and maintenance activities. (Courtesy of the Library of Congress, Prints and Photographs Division, FSA-OWI Collection.)

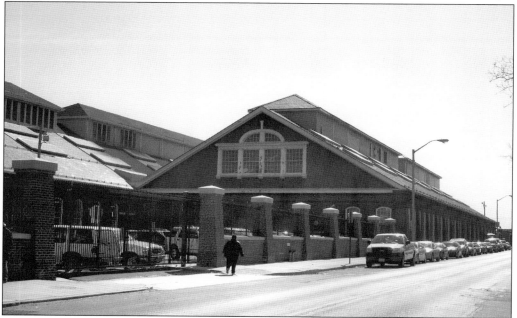

Today the Carroll Park Shops are something of an oddity, in that the facility is still used for what it was originally built for: it provides offices and repair facilities for the Maryland Transit Administration. (Courtesy of the author.)

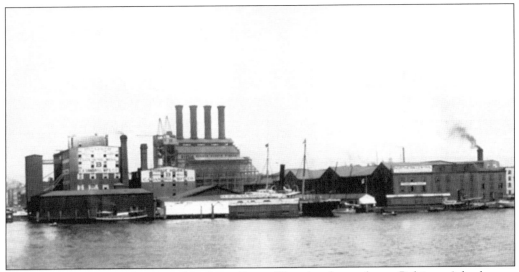

The distinct profile of the United Railways Power Plant has loomed over Baltimore's harbor on Pier 4 for over a century. This facility provided power to one of the city's many streetcar lines. (Courtesy of the Library of Congress.)

The power plant was successfully renovated in the late 1990s into a mixed-use development, combining retail and commercial office space while retaining the historic character of both the exterior and interior. (Courtesy of the author.)

Seven

EVOLUTION OF
THE HARBOR

Baltimore's history can be told through the changes witnessed around the Inner Harbor over time. For most of Baltimore's existence, the harbor was considered a dirty, dangerous place. Frequently polluted and surrounded by factories and other noxious uses, the water was seen as a utilitarian resource to be exploited to transport goods and materials rather than a tourist destination.

It has only been within the last quarter-century, with the Rouse Company's development of the Inner Harbor pavilions and the establishment of popular tourist venues such as the National Aquarium in Baltimore and the Maryland Science Center, that the image of the harbor has turned around and is now seen as a positive asset in its own right. Currently there is a new phase of development overtaking the harbor with the establishment of a variety of residential uses on the waterfront. Creating high-end residences right on the water would have seemed absolutely ludicrous to someone familiar with the sights, sounds, and smells traditionally associated with Baltimore's historically active waterfront.

As Baltimore's harbor has changed, so has the entire city. Baltimore has been transformed, sometimes painfully, from an industrial center with a strong emphasis on manufacturing and import/export through the port to a post-industrial economy emphasizing finance and tourism with the port playing a diminished, yet still important, role.

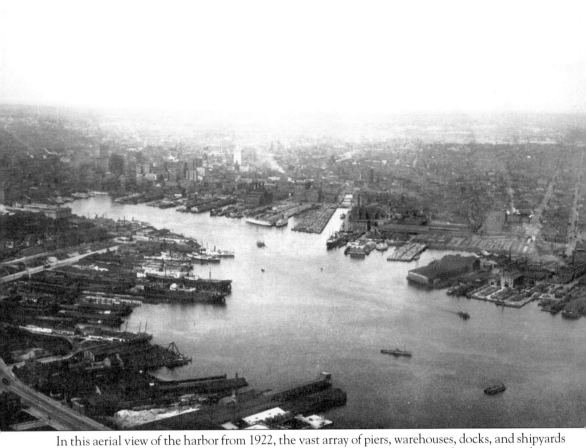

In this aerial view of the harbor from 1922, the vast array of piers, warehouses, docks, and shipyards that ring the harbor are all visible. Most of these features have disappeared over time as the city has continually reinvented itself. (Courtesy of the Baltimore City CHAP.)

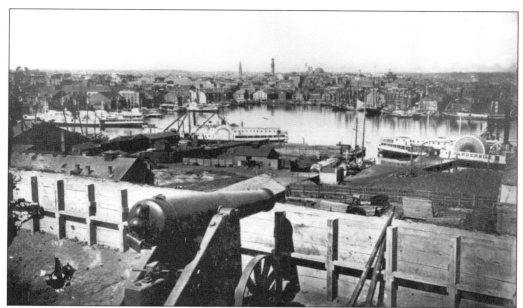

In this photograph from 1862, Union cannons trained on the harbor are visible, and the relatively low-scale development of the city is apparent, with several church spires, the Basilica of the National Shrine of the Assumption of the Blessed Virgin Mary, and the Washington Monument clearly visible over the two- and three-story buildings surrounding the harbor. (Courtesy of the Enoch Pratt Free Library, Central Library/State Library Resource Center, Baltimore, Maryland.)

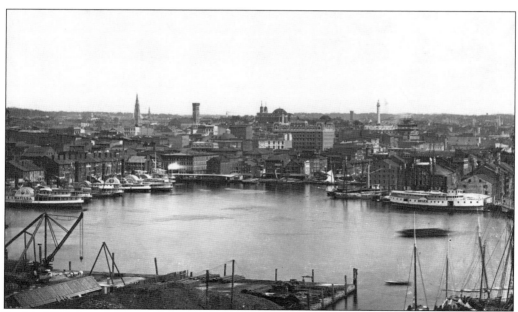

In this 1872 photograph, grander commercial buildings are becoming visible on the north and west sides of the harbor, marking the rise of larger commercial interests. (Courtesy of the Enoch Pratt Free Library, Central Library/State Library Resource Center, Baltimore, Maryland.)

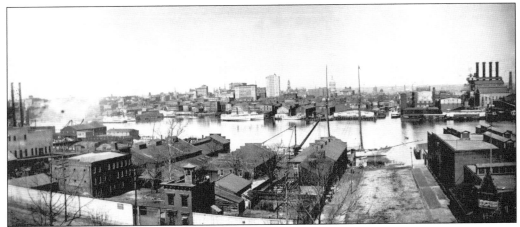

This view from 1900 highlights several profound changes to the harbor. The United Railways Power Plant is now visible on the right side of the image, and the area immediately below Federal Hill is now filled with an assortment of commercial structures. (Courtesy of the Enoch Pratt Free Library, Central Library/State Library Resource Center, Baltimore, Maryland.)

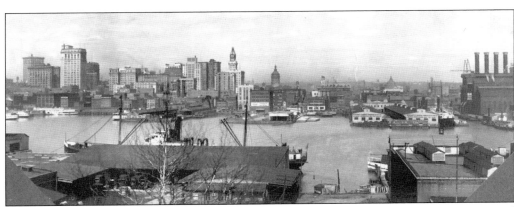

In this photograph from 1925, there are now significantly more high-rises visible in the Central Business District, and there are fewer, larger industrial structures on the land below Federal Hill. (Courtesy of the Enoch Pratt Free Library, Central Library/State Library Resource Center, Baltimore, Maryland.)

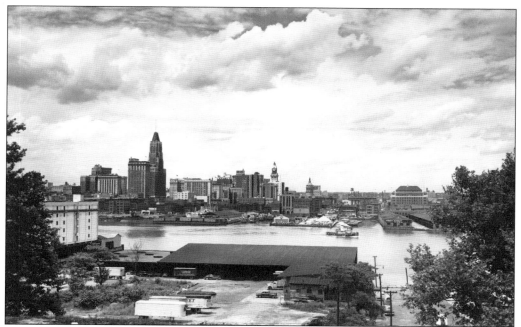

In 1950, there is a slightly less cluttered appearance to the harbor, as larger, more substantial structures are constructed on both sides of the harbor. (Courtesy of the Enoch Pratt Free Library, Central Library/State Library Resource Center, Baltimore, Maryland.)

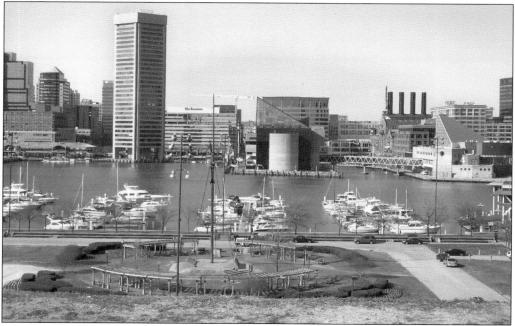

Today the harbor is completely transformed, with all vestiges of industry around the Inner Harbor replaced with tourist destinations such as the National Aquarium. Even the United Railways Power Plant has been converted from an industrial use to a popular tourist destination. (Courtesy of the author.)

Discover Thousands of Local History Books
Featuring Millions of Vintage Images

Arcadia Publishing, the leading local history publisher in the United States, is committed to making history accessible and meaningful through publishing books that celebrate and preserve the heritage of America's people and places.

Find more books like this at
www.arcadiapublishing.com

Search for your hometown history, your old stomping grounds, and even your favorite sports team.

Consistent with our mission to preserve history on a local level, this book was printed in South Carolina on American-made paper and manufactured entirely in the United States. Products carrying the accredited Forest Stewardship Council (FSC) label are printed on 100 percent FSC-certified paper.

MADE IN THE USA